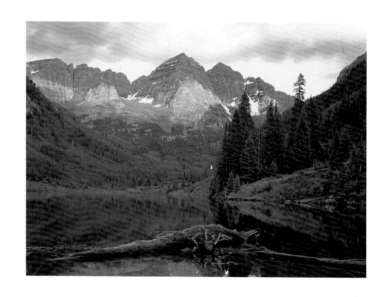

COLORADO

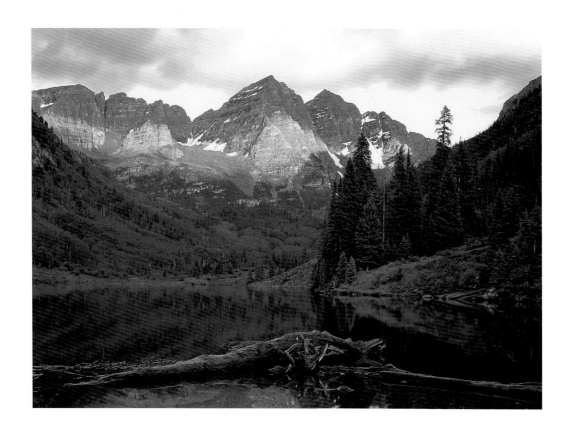

WHITECAP BOOKS
VANCOUVER / TORONTO

The information in this book is true and complete to the best of our knowledge. All
recommendations are made without guarantee on the part of the author or Whitecap
Books Ltd. The author and publisher disclaim any liability in connection with the use
of this information. For additional information please contact Whitecap Books Ltd.,
351 Lynn Avenue, North Vancouver, BC V7J 2C4.

Text by Tanya Lloyd
Edited by Elizabeth McLean
Photo editing by Tanya Lloyd
Proofread by Lisa Collins
Cover and interior design by Steve Penner
Desktop publishing by Susan Greenshields
Printed and bound in Canada

Canadian Cataloguing in Publication Data

Lloyd, Tanya, 1973–

 Colorado

 ISBN 1-55110-946-8

1. Colorado—Pictorial works. I. Title.
F777.L54 1999 978.8'033'0222 C99-910828-X

The publisher acknowledges the support of the Canada Council and the Cultural
Services Branch of the Government of British Columbia in making this publication
possible. We acknowledge the financial support of the Government of Canada through
the Book Publishing Industry Development Program for our publishing activities.

For more information on the America Series and other Whitecap Books
titles, please visit our web site at www.whitecap.ca.

Colorado takes you by surprise. One moment you're driving on the quiet, tree-lined streets of Boulder and then—seemingly just a few turns later—you're high in the rugged peaks of the Rocky Mountains. Cliffs drop sharply from the highway's edge, and panoramic views spread before you.

Colorado's mountains are spellbinding, and it's easy to see why tourism and recreation have become leading industries. With more than 35 percent of the state designated as public land, skiers, mountain bikers, hikers, rafters, and thousands of sightseers flock here each year.

Because of its high alpine passes and harsh winters, this region was populated later than the surrounding states. The gold rush finally brought settlers in the late 1850s, when prospectors and adventure-seekers arrived under the banner "Pikes Peak or Bust." In the early 1860s, Colorado's mines were producing 150,000 ounces of gold each year, but the mountains had been nearly stripped of their treasure by the end of the decade.

Mark Twain called one Colorado community he visited "the wickedest city in the west." In 1889, Butch Cassidy robbed his first bank in Telluride. Billy the Kid is another well-known past resident. The state remains steeped in memories of this wild frontier heritage. From the dilapidated mines scattered through state forests to the false-fronted shops lining historic town streets, the atmosphere of adventure still lingers.

Of course, Colorado is not all mountain peaks and remote ranching communities. The capital city of Denver has been recognized as one of the best places in America to do business, and citizens boast more university degrees per capita than people in any other state. Visitors seeking world-class shopping, state-of-the-art museums, or contemporary architecture will find it easily in Colorado. If they leave the ski slopes.

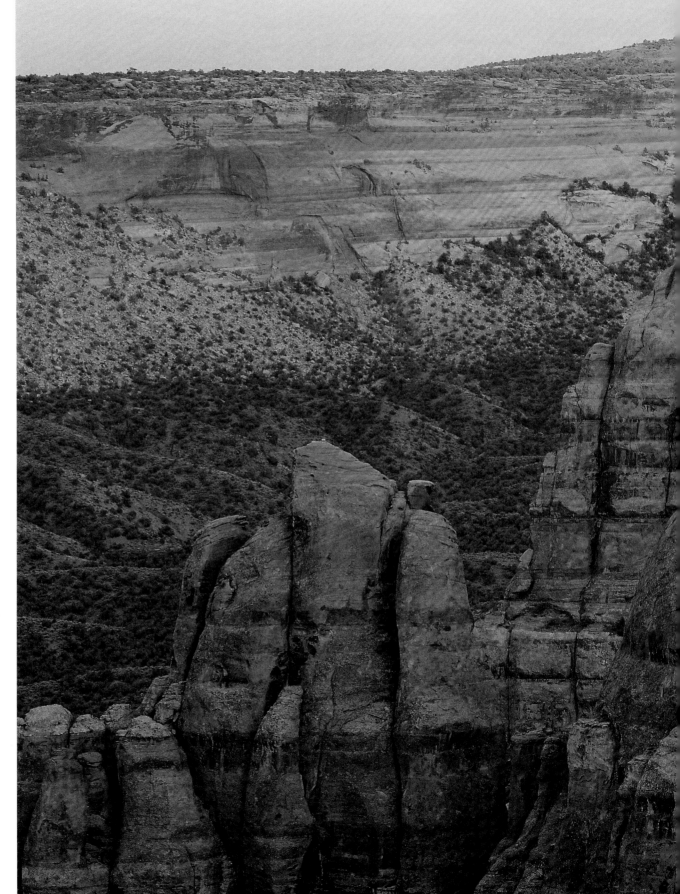

The 32-square-mile Colorado National Monument encompasses a portion of the Grand Valley, an eerie landscape carved by the Colorado River. The preserve was established in 1911, after area resident and guide John Otto had lobbied for years for its protection.

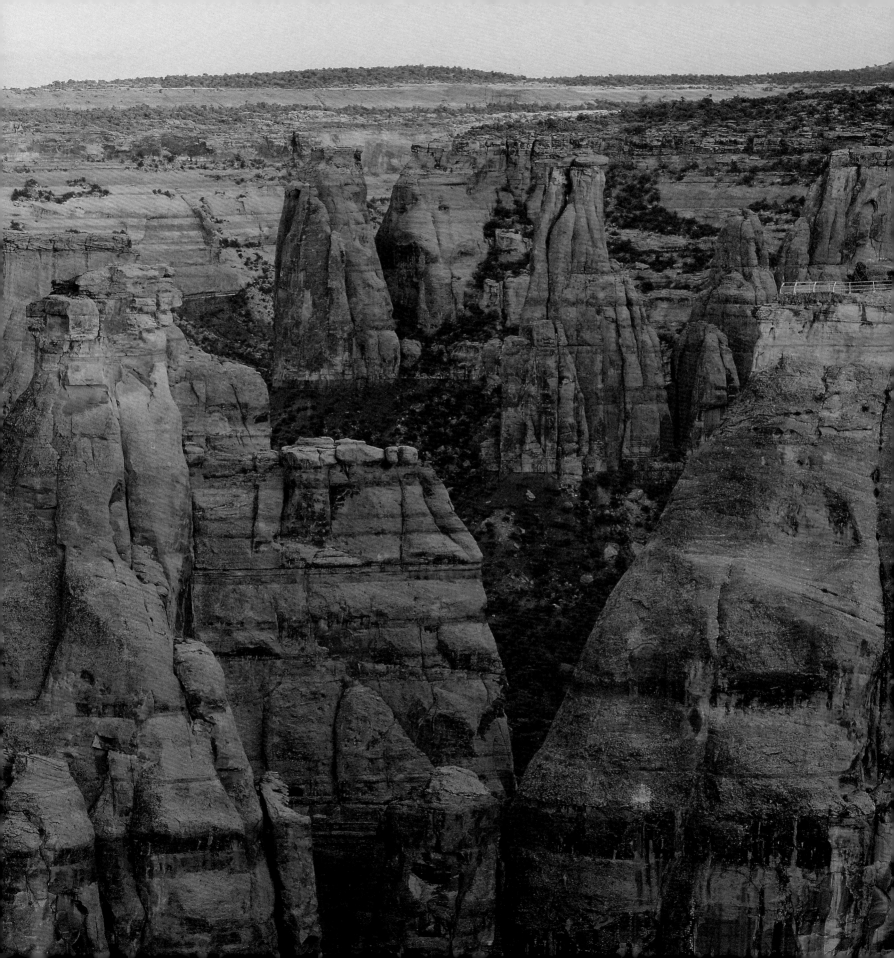

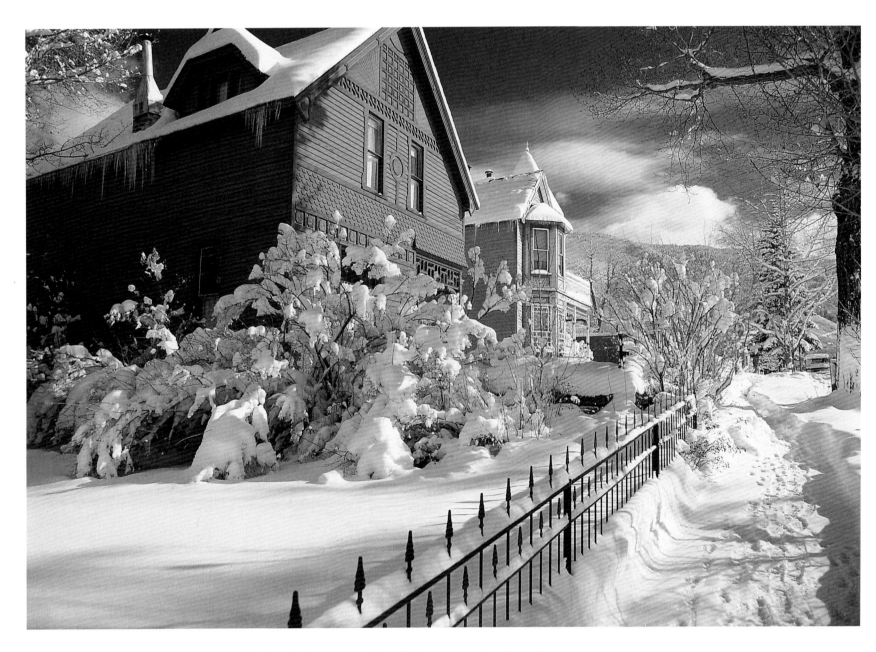

Although many are new or refurbished, Aspen's buildings retain the character and charm of the community's Victorian-era silver-rush beginnings.

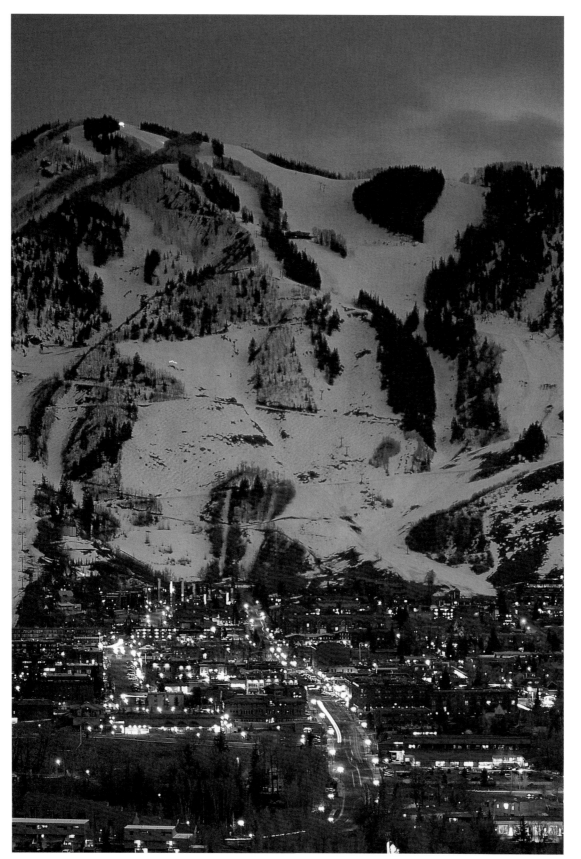

Once a mining town, Aspen is now a glamorous celebrity playground. Besides skiing, the community offers numerous events and festivals, from January's Wintersköl to the summer's Aspen Music Festival and Snowmass Balloon Festival.

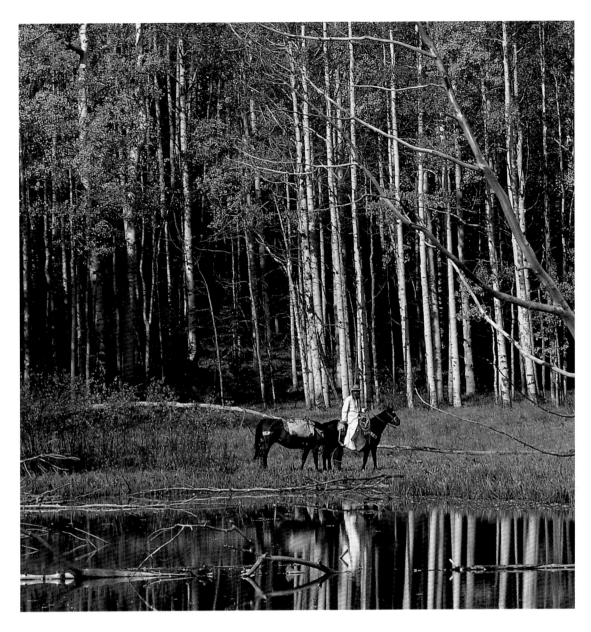

Outfitters near Aspen offer trail rides and hourly horse rentals, as well as guided multi-day excursions into the area's mountain passes.

A backpacker reaches glistening Snowmass Lake—a perfect reward for a hike in the Maroon Bells–Snowmass Wilderness. The wilderness extends through parts of the White River and Gunnison national forests, offering more than 100 miles of trails.

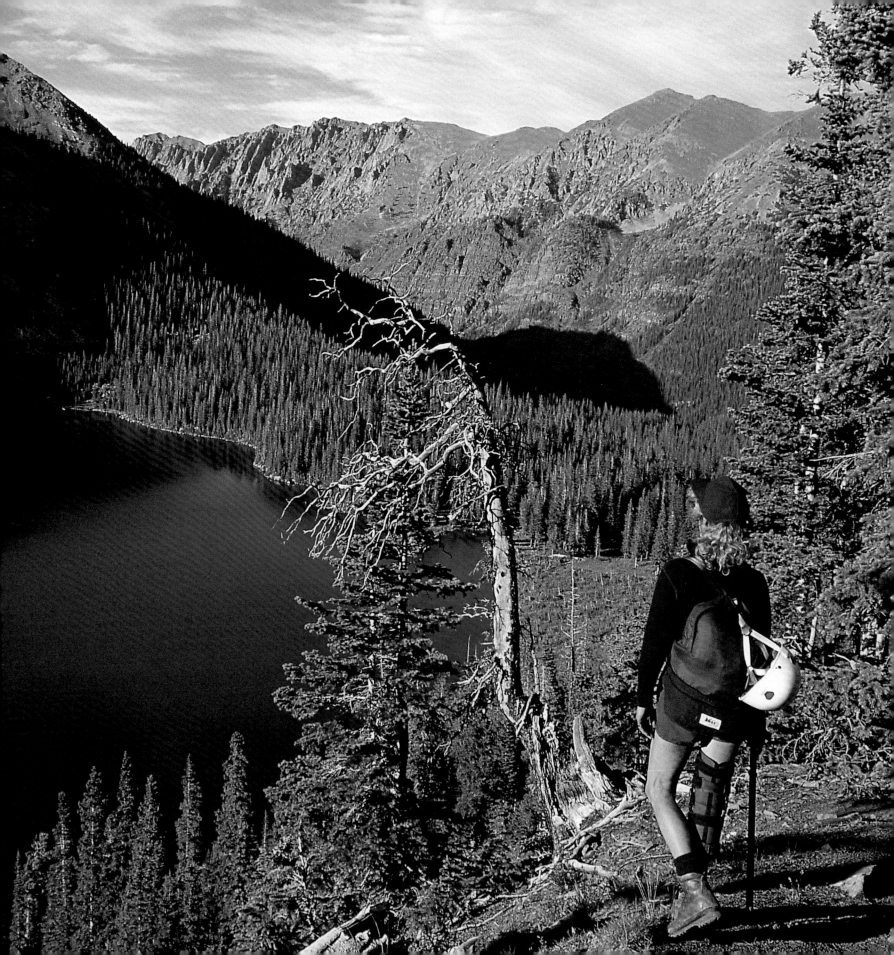

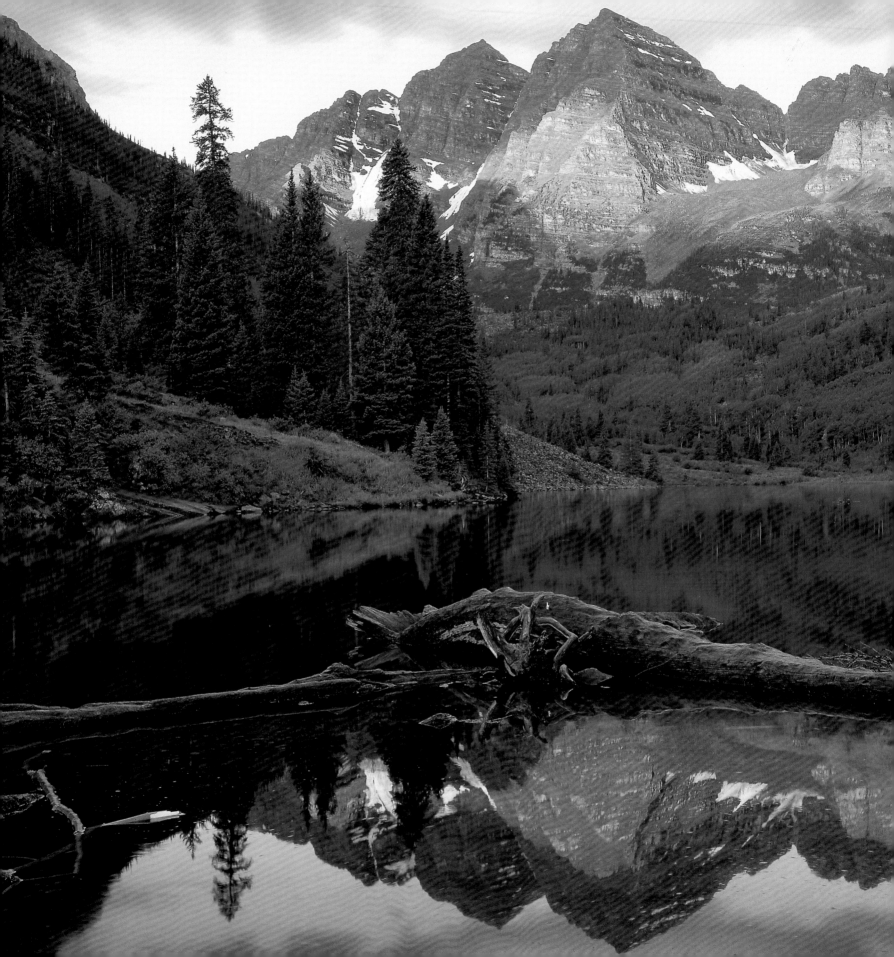

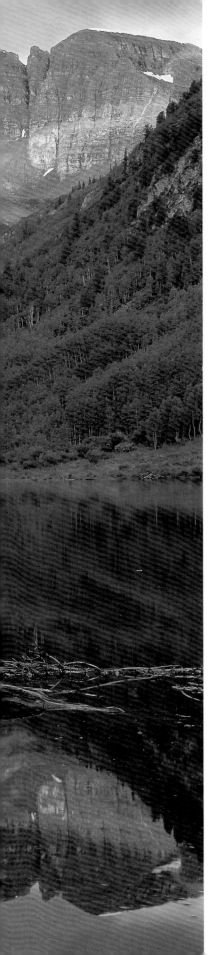

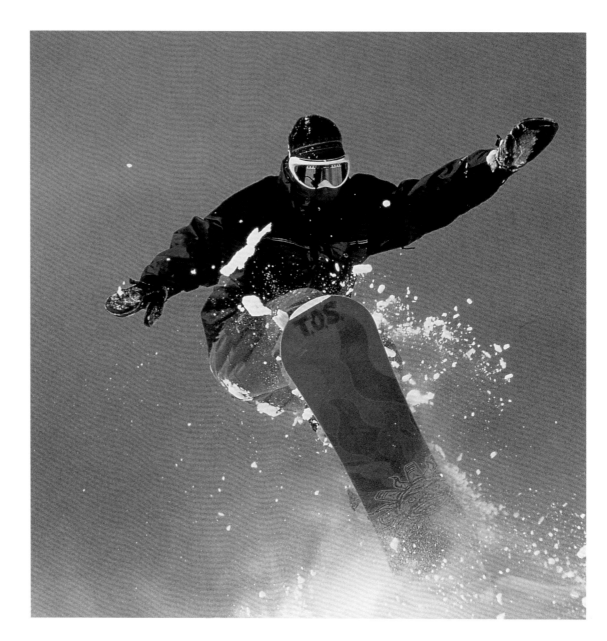

A snowboarder enjoys a clear day on Aspen's slopes.

Just a short drive takes Aspen visitors to the base
of Maroon Bells, Colorado's most photographed
mountains. This part of White River National Forest
is one of the state's most popular wilderness stops.

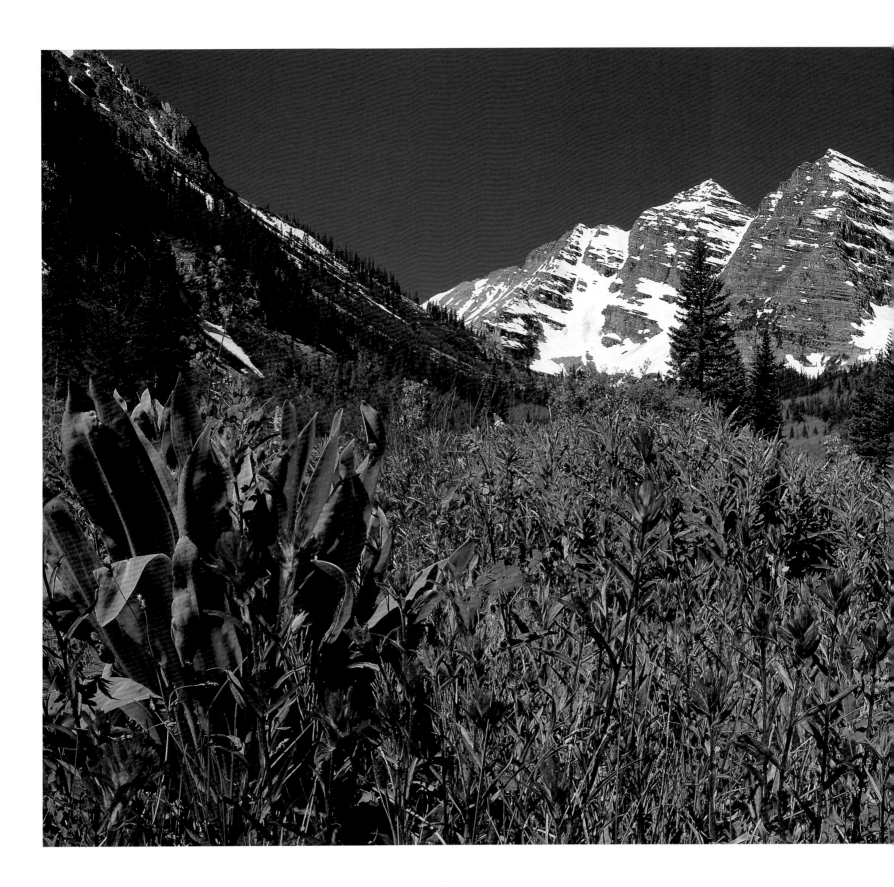

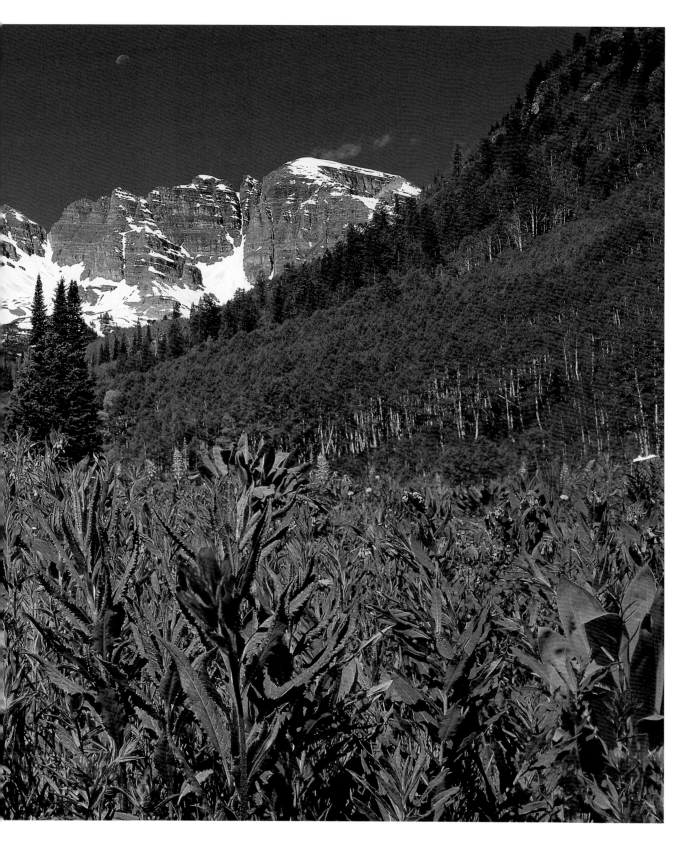

Paintbrush and blue-bells adorn a hillside in White River National Forest. The country's first forest preserve, the 2.25-million-acre area was set aside in 1891.

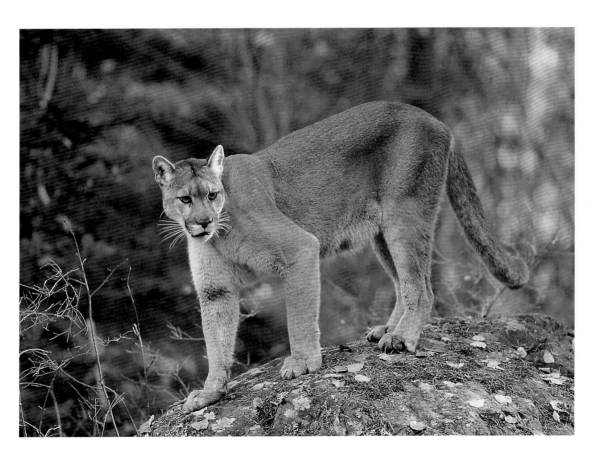

Seldom seen, the cougar is one of the most dangerous predators of the state's forests, hunting small rodents, bear cubs, otters, raccoons, and deer. The wild cat is capable of killing an elk three times its size.

The Swiss-style mountain village of Vail was secretly built in 1961. Revealed in 1962, it drew national attention and the mountain resort has since become the country's largest skiing destination.

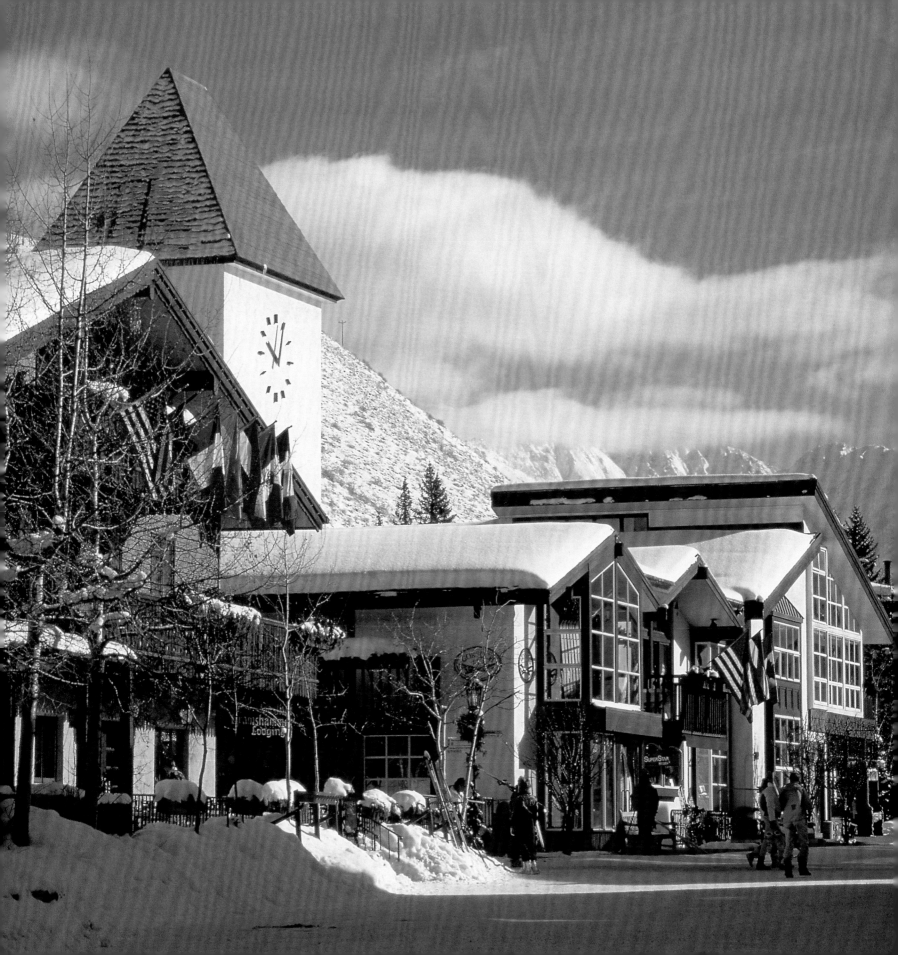

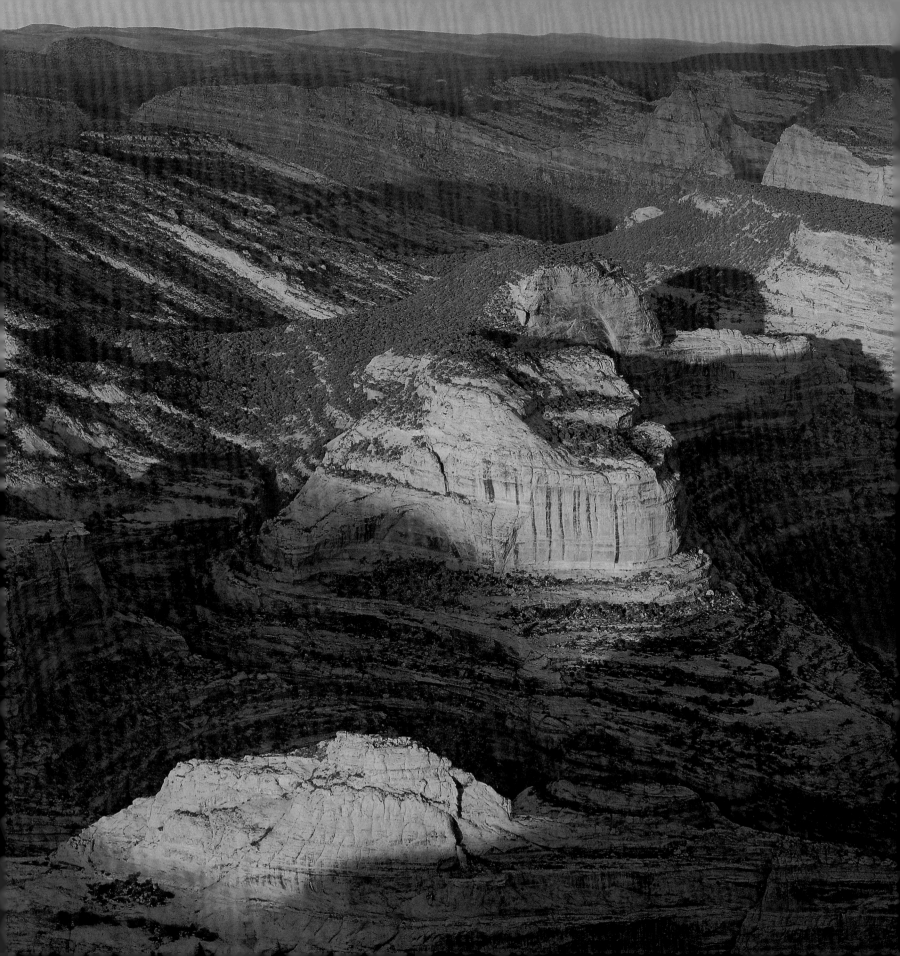

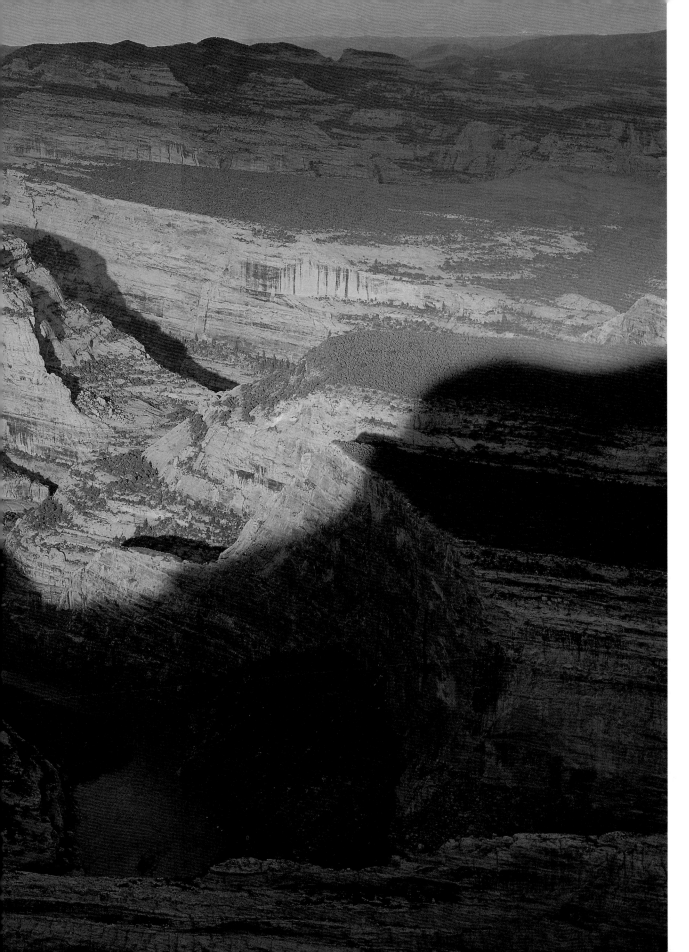

In 1909, paleontologist Earl Douglas discovered the bones of a brontosaurus in what is now Dinosaur National Monument. Since then, more than 350 tons of bones and fossils have been unearthed. Few roads enter the reserve, which stretches across the Utah border.

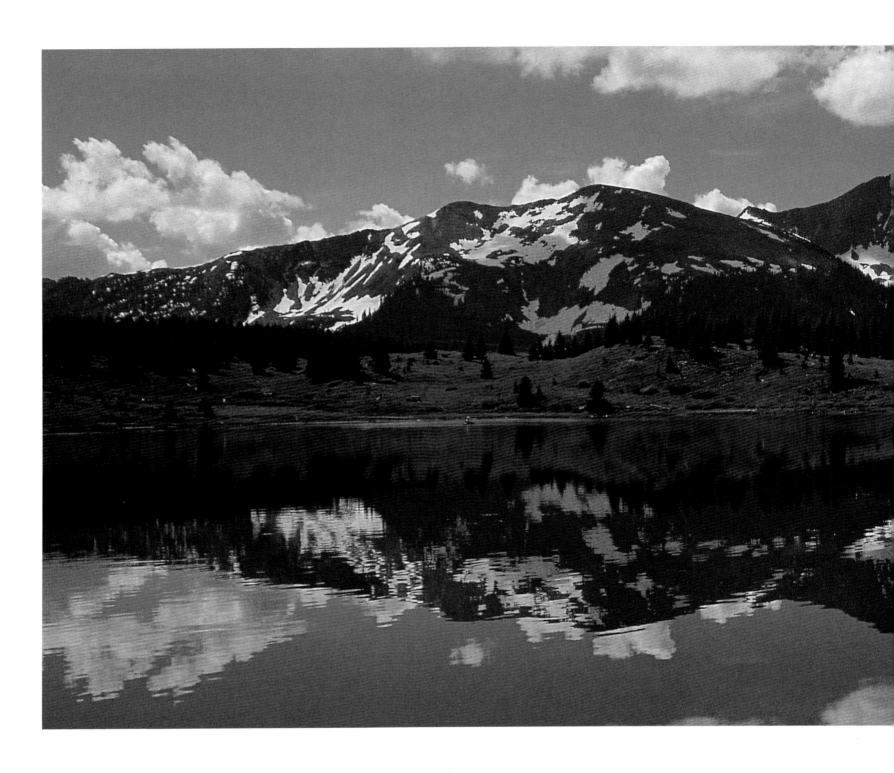

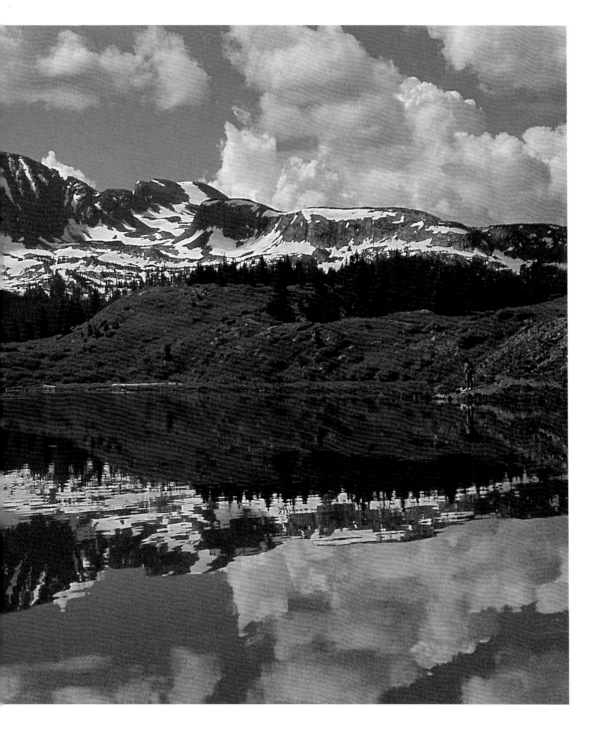

Little Molas Lake glistens under the peaks of the Rockies. Colorado boasts almost 3,000 lakes and 7,000 miles of streams, many fed by icy glacial water.

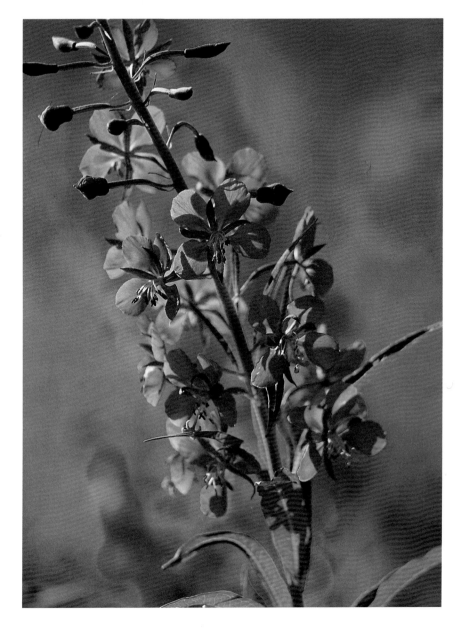

Abundant on the slopes of the Rockies, fireweed waves distinctive pink and purple plumes. Native people have traditionally used the plant to treat bruises and infection.

Cross-country skiers can choose between groomed runs at many of Colorado's ski hills, or explore one of the state's wilderness areas.

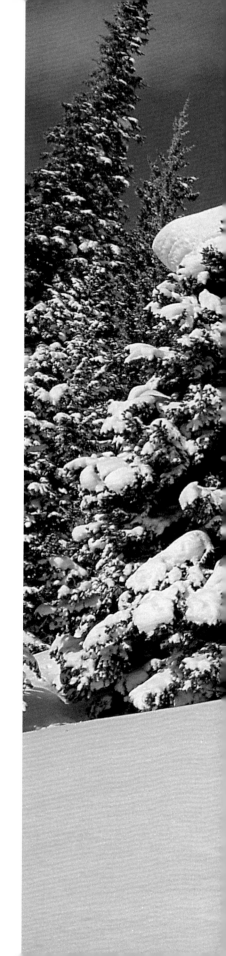

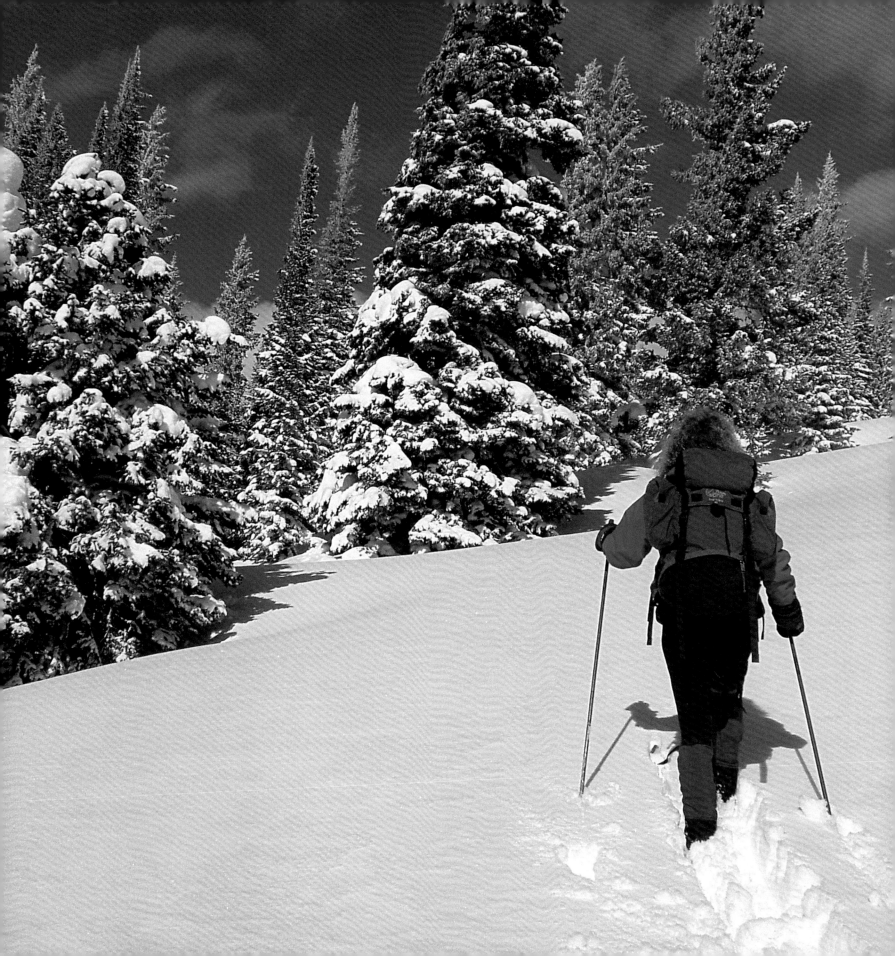

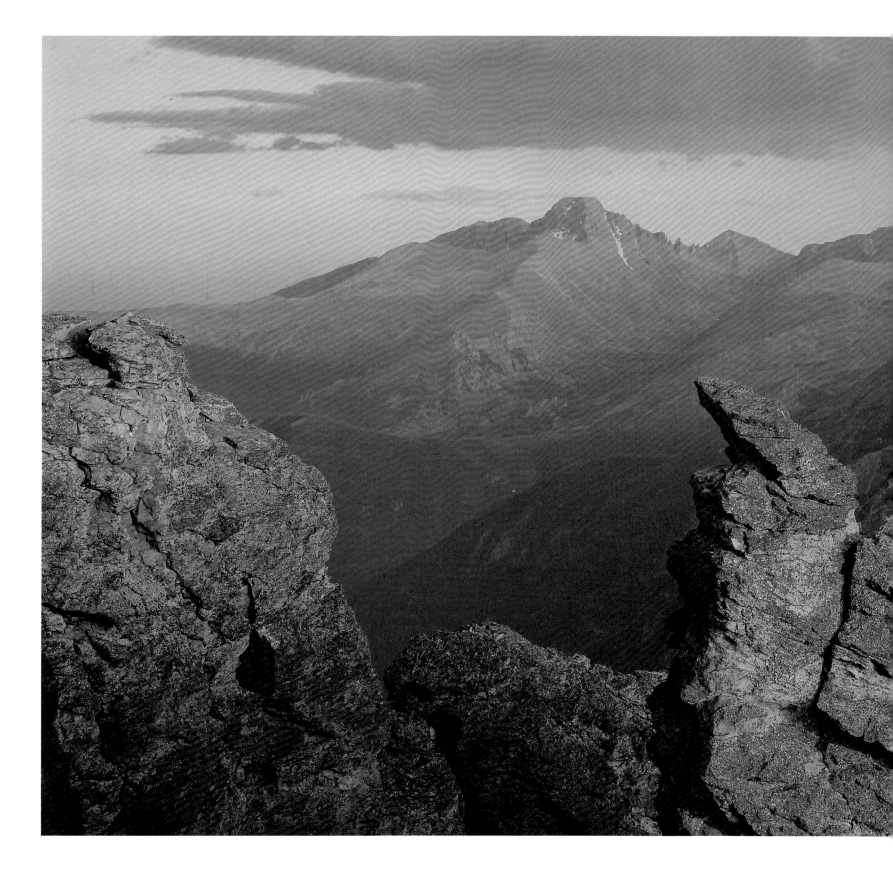

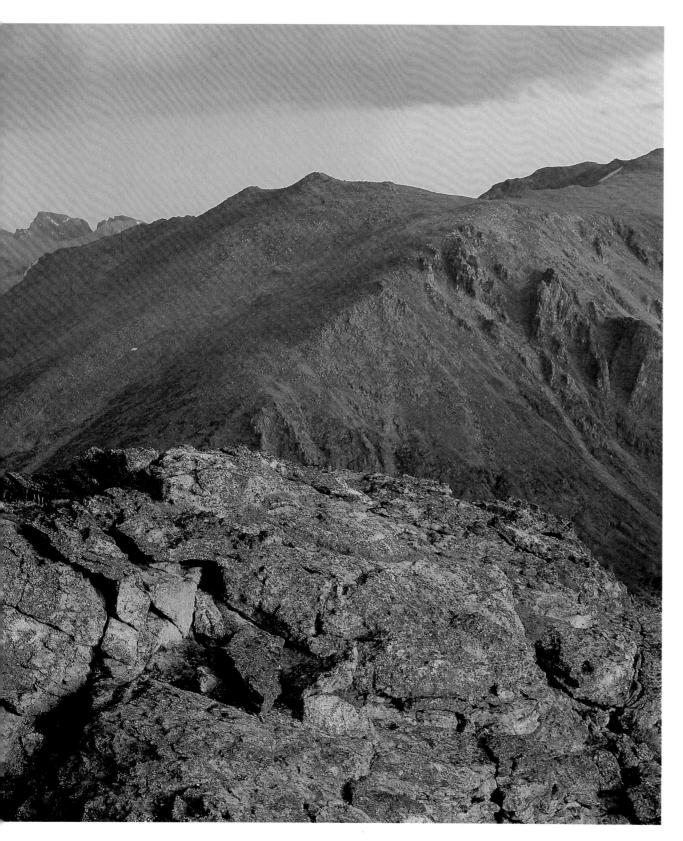

The Rocky Mountains reach their greatest height and width in Colorado—just one reason Rocky Mountain National Park is the state's largest and most visited preserve.

President Woodrow Wilson declared Rocky Mountain National Park
the country's 10th national park in 1915. The UN designated the area
a Biosphere Reserve 60 years later.

Feeding in the meadows and often along the roadsides,
elk are some of the most often seen and photographed
of Colorado's big game. Elk herds frequently wander to
the boundaries of the Estes Park townsite.

26

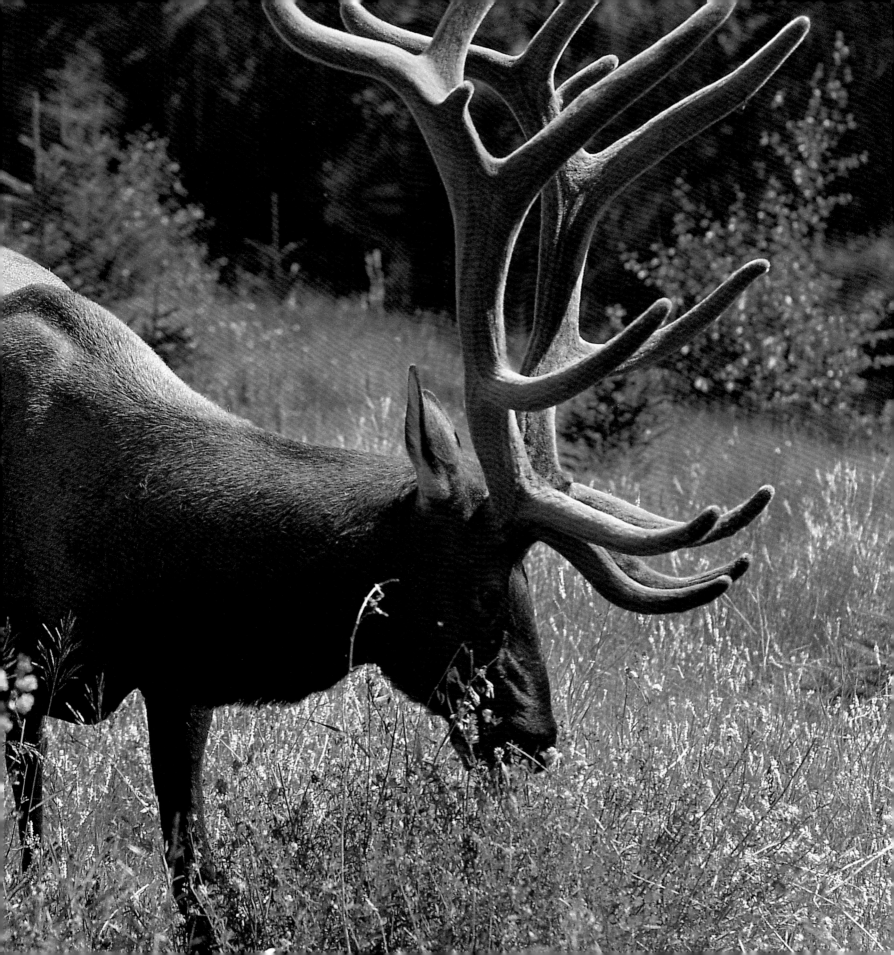

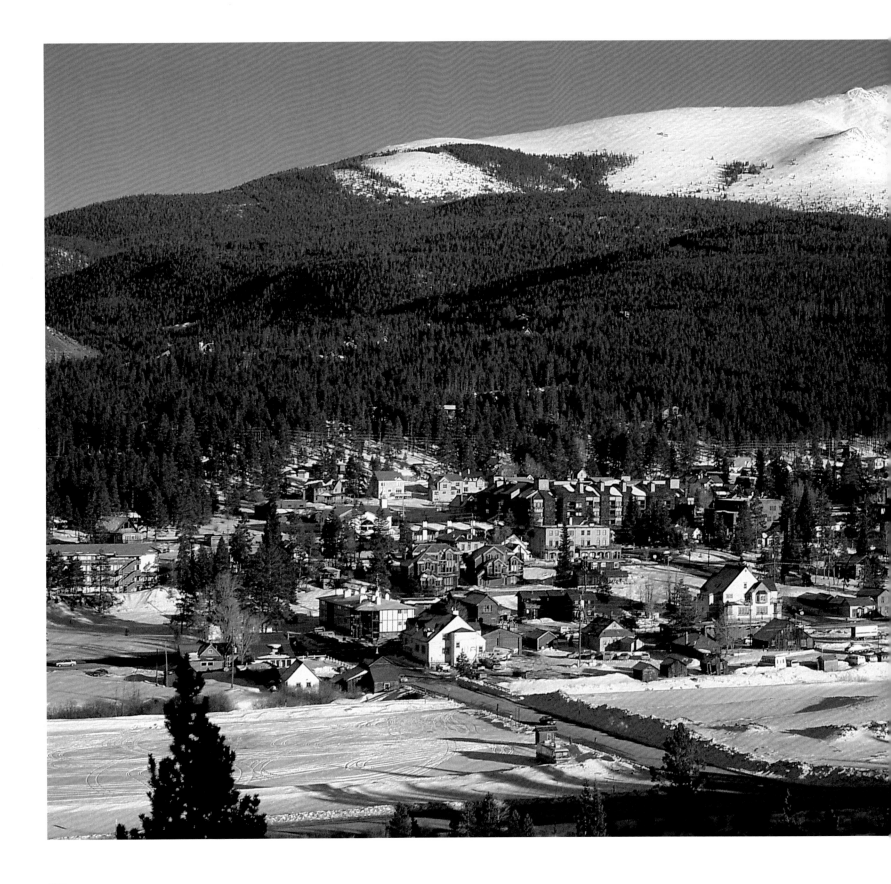

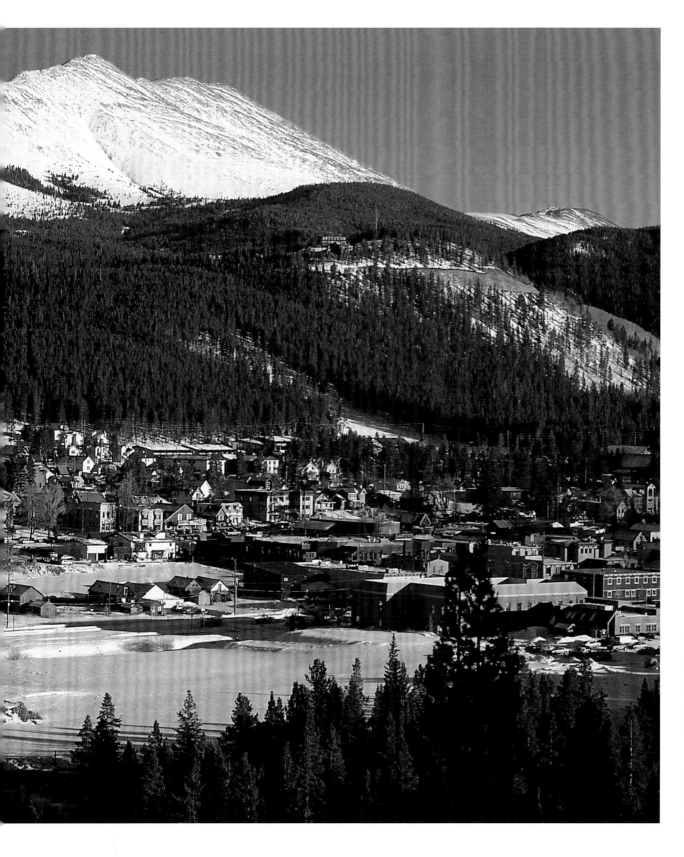

The altitude at the base of Arapahoe Basin, one of four ski areas in Summit County, is almost 11,000 feet. Ski season here has been known to last until July.

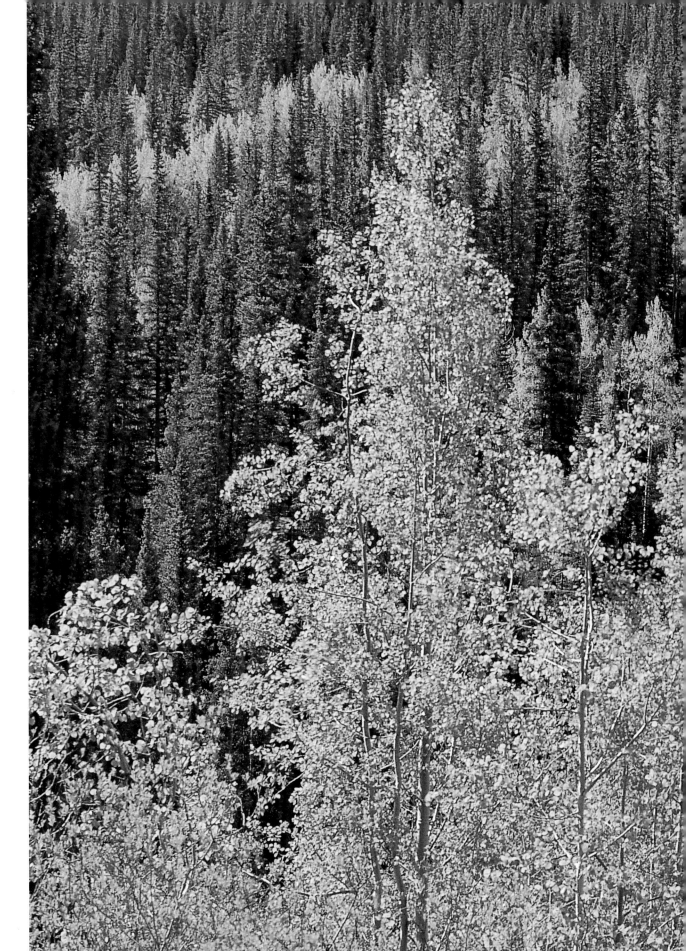

Prospectors poured into Colorado's mountains after gold was found in 1858. Three years later, mines were producing 150,000 ounces of gold annually. When the supply dwindled in the late 1860s, miners slowly left the state or turned to mining silver, zinc, and lead.

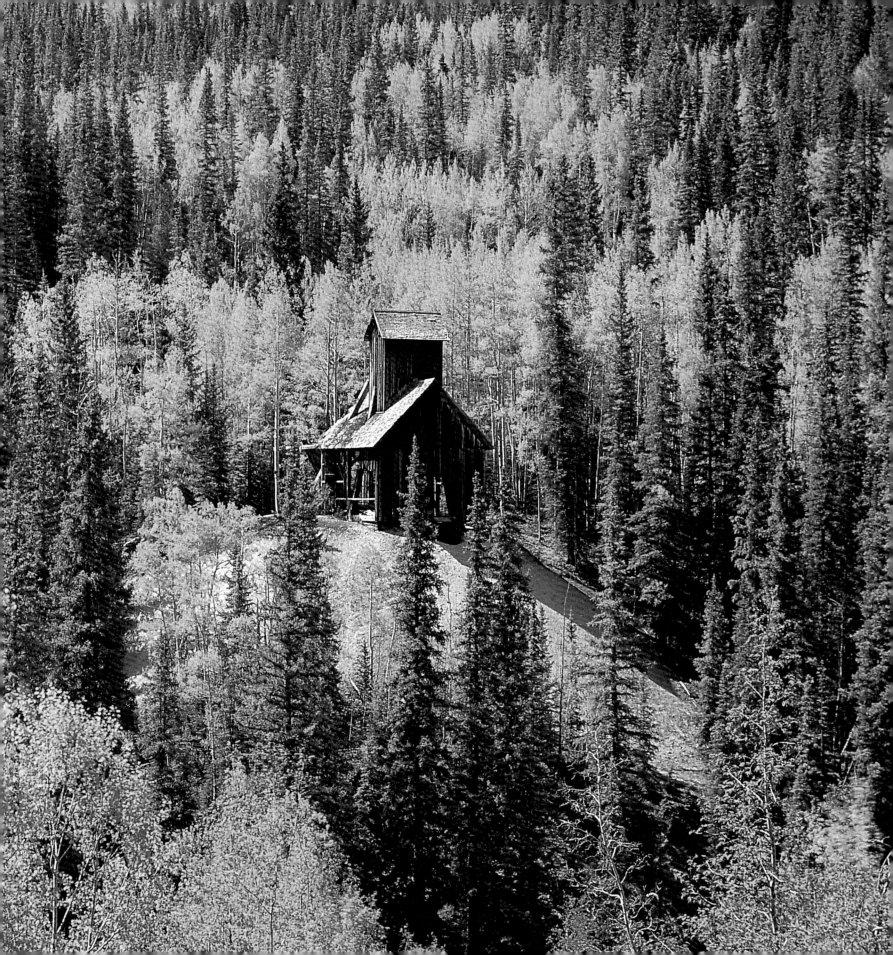

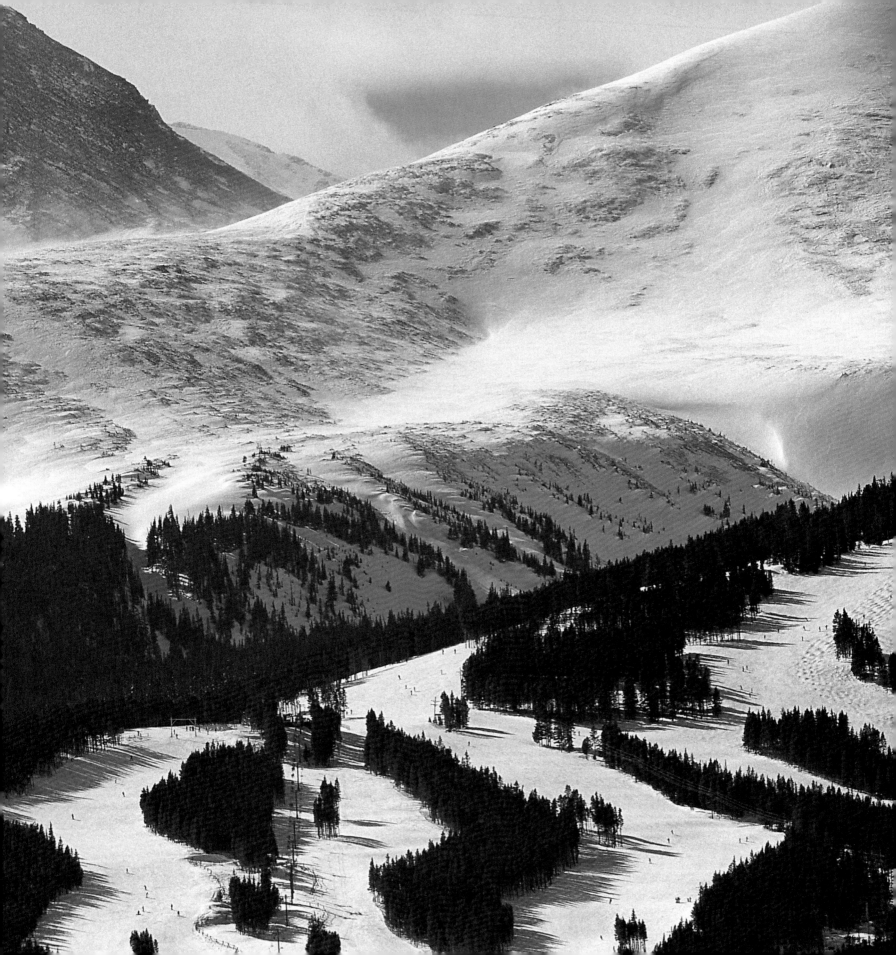

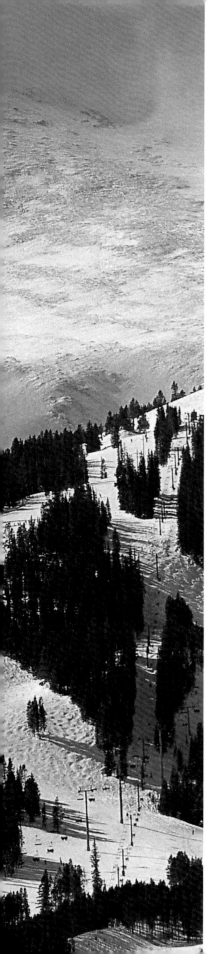

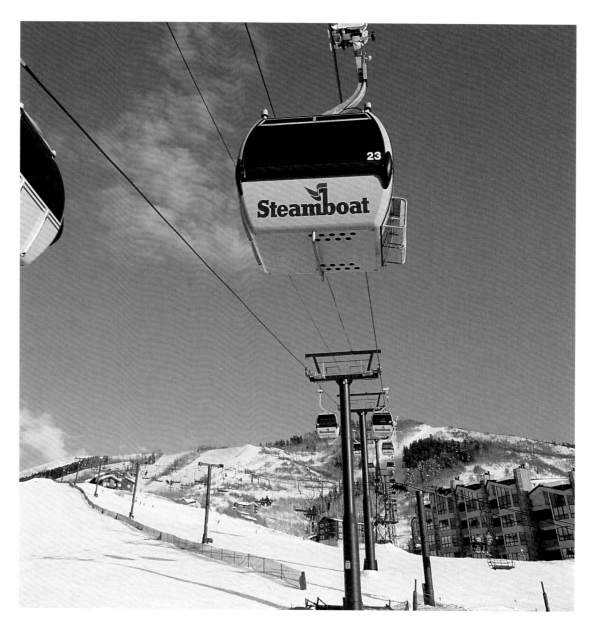

Visitors to Steamboat Springs can choose to glide through the powder at the local ski area or bathe in the nearby pools, fed by some of more than 150 mineral springs that surround the community.

A favorite ski area for Denver residents, Breckenridge offers runs on four summits. The town was founded with the gold rush in 1859. Its quaint downtown buildings are a reminder of the past.

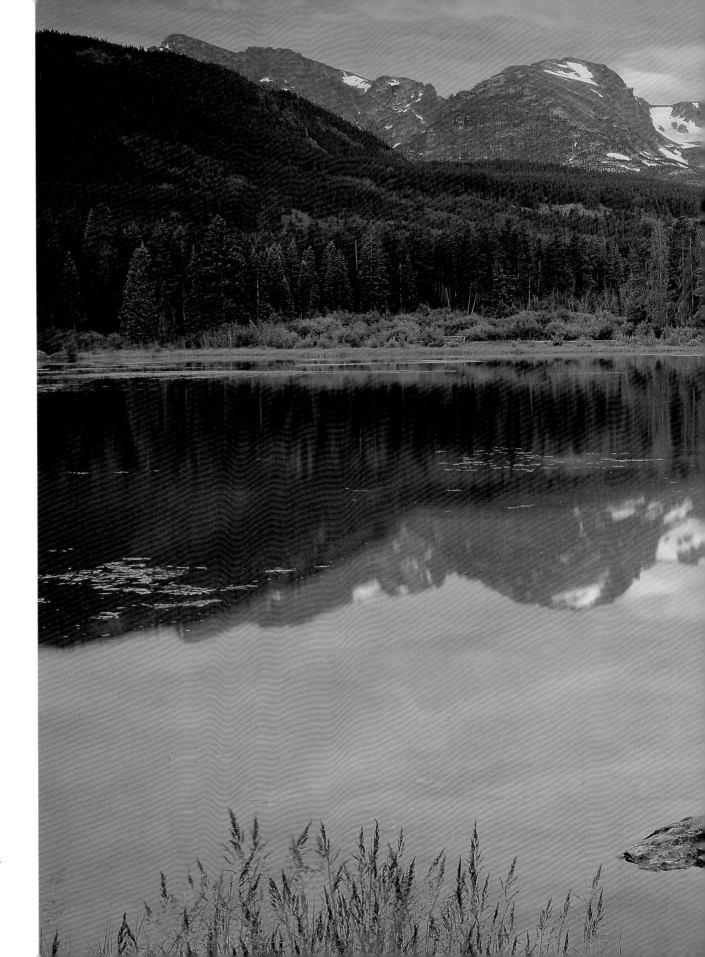

Dawn sheds a rosy light on Otis Peak, Hallett Peak, and Flattop Mountain. Well-groomed trails throughout Rocky Mountain National Park lead through forested valleys and towards rugged peaks such as these.

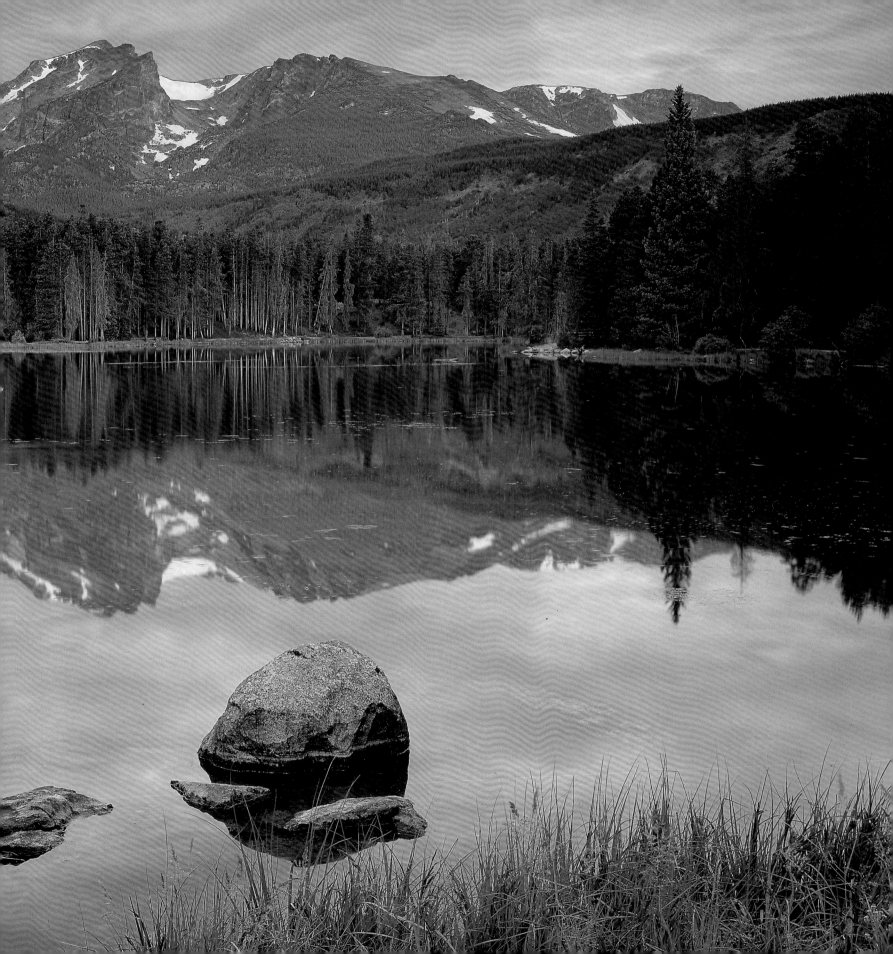

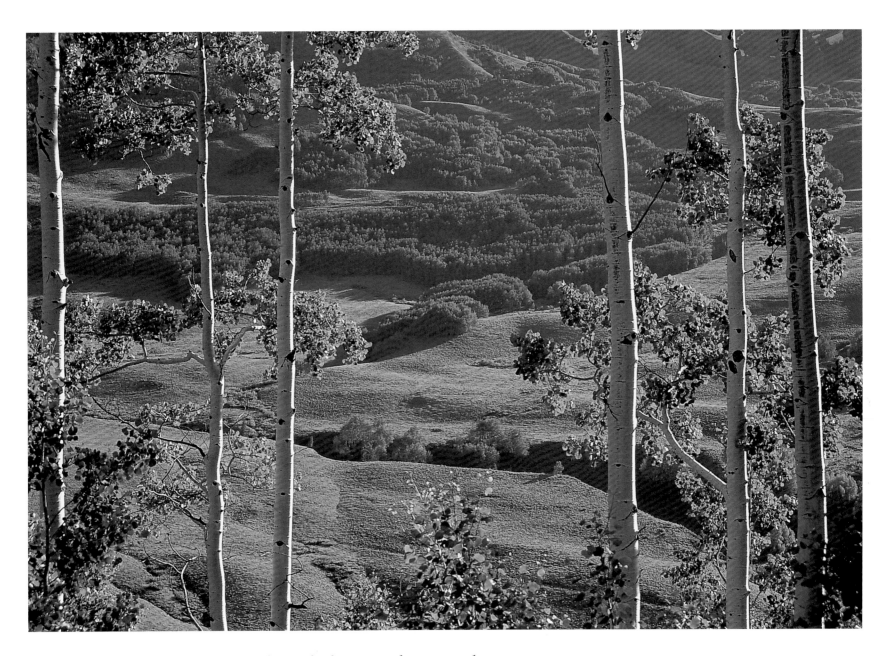

Afternoon breezes send ripples through the aspen leaves in this picturesque grove near St. Elmo.

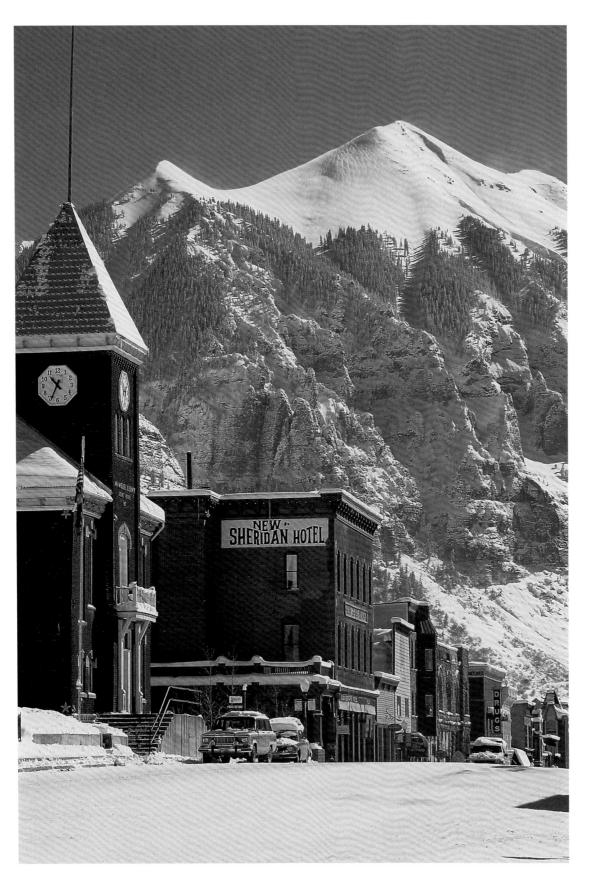

Telluride began in the 1870s as a tent city of prospectors. Today, people seek a different kind of adventure here, drawn by 13 ski lifts and 1,050 acres of skiable terrain.

Home to the main campus of the University of Colorado, Boulder is known as one of the state's friendliest cities. Visitors can ride along the shaded bike paths, explore the Pearl Street Mall, or taste exotic teas at the head office of Celestial Seasonings.

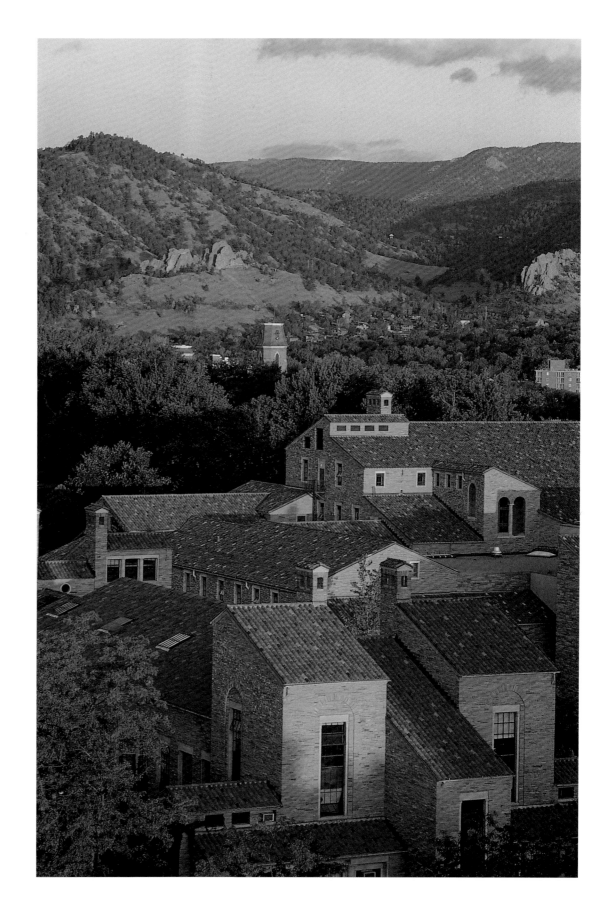

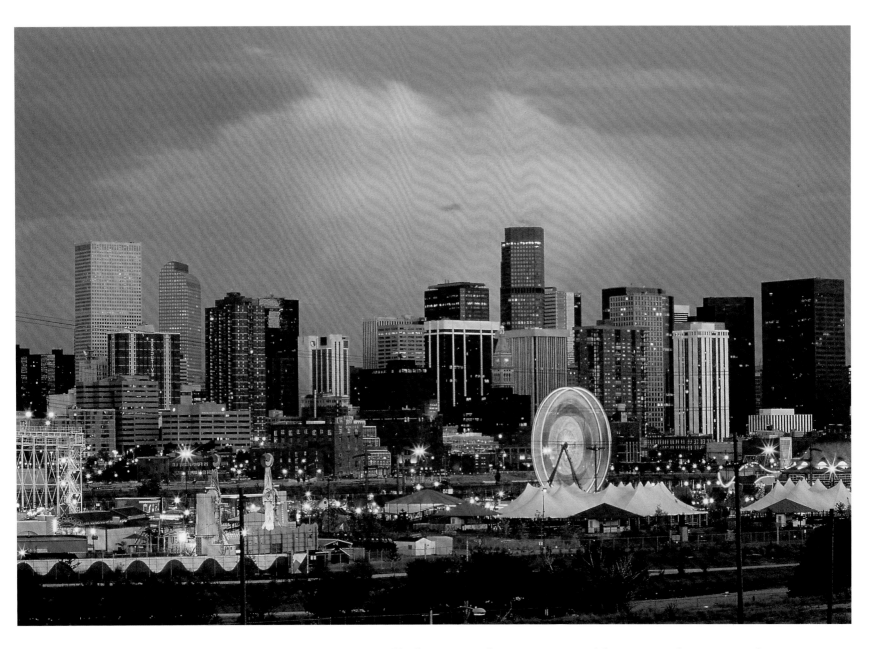

Originally home to the ancient Puebloan people, Denver became a stop on the gold rush trail after prospectors struck it rich in the area. It was known in the mid-1800s as one of the roughest frontier towns in the country.

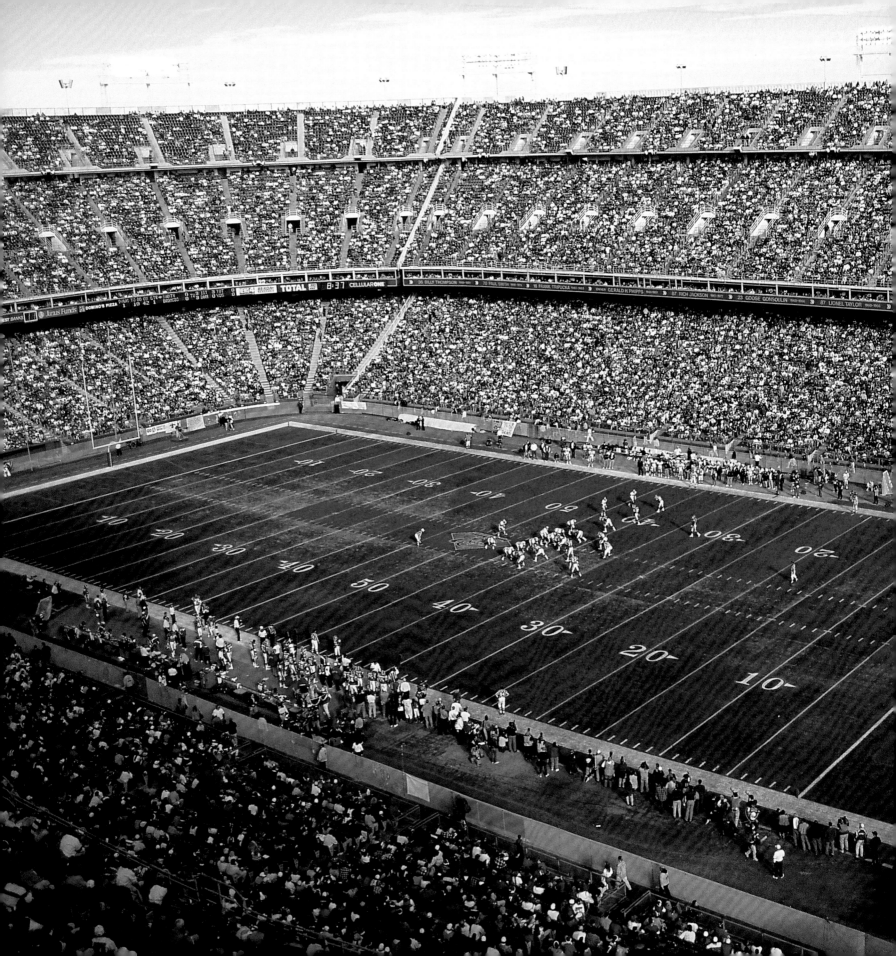

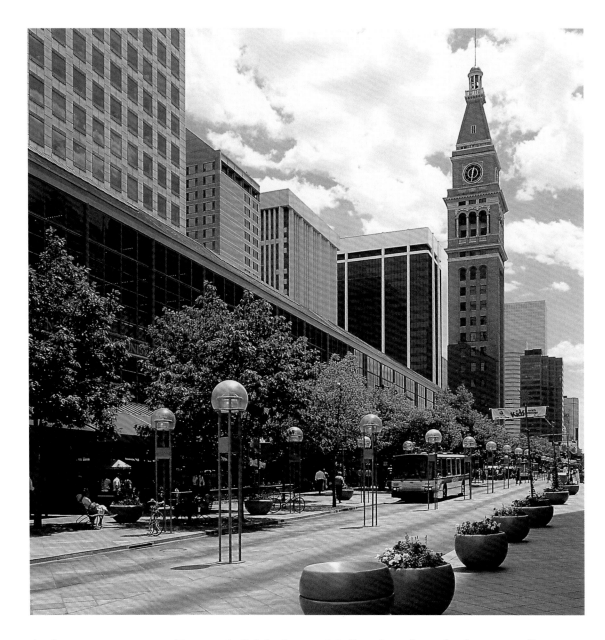

A shopping mecca, Denver's 16th Street Mall is lined with shops, galleries, and restaurants.

More than 76,000 fans cheer the Broncos to victory at Mile High Stadium.

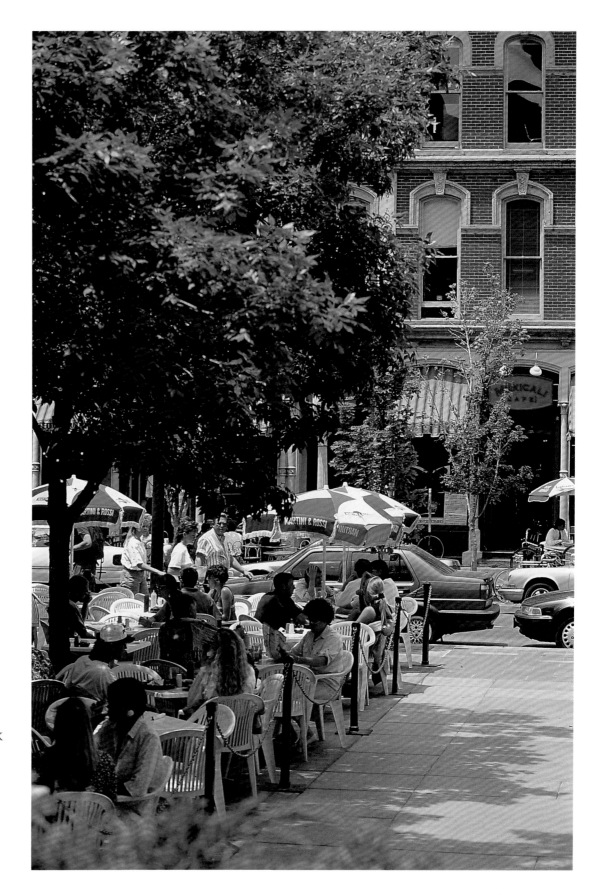

The city's oldest commercial area, Larimer Square's boutiques and bistros mark the entrance to Denver's historic district. Much of this area was built in the late 19th century.

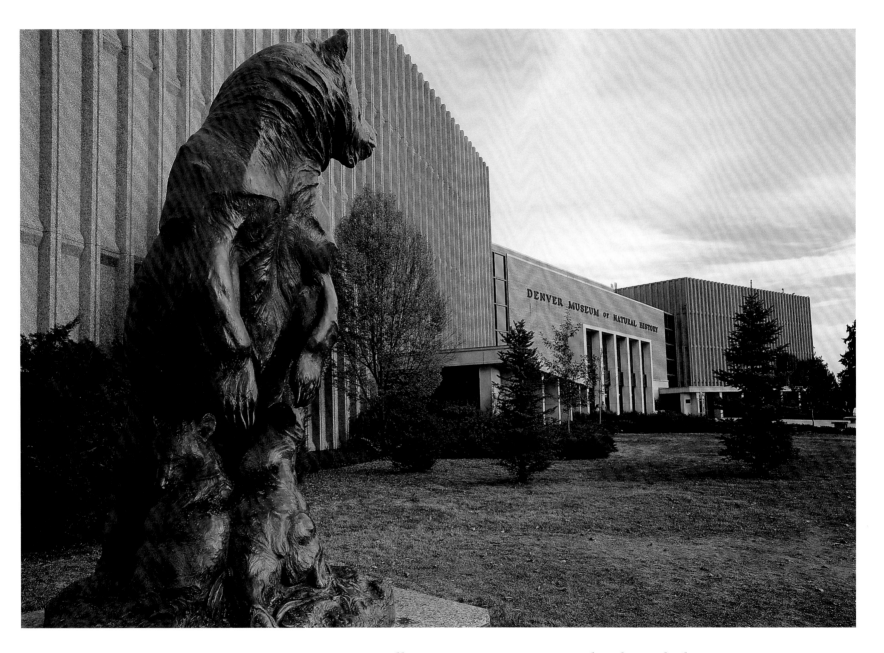

Two million visitors per year wander through the Denver Museum of Natural History, gleaning information on topics from the human body and Colorado gold to dinosaur fossils and Native culture. The facility also boasts a planetarium and an IMAX theater.

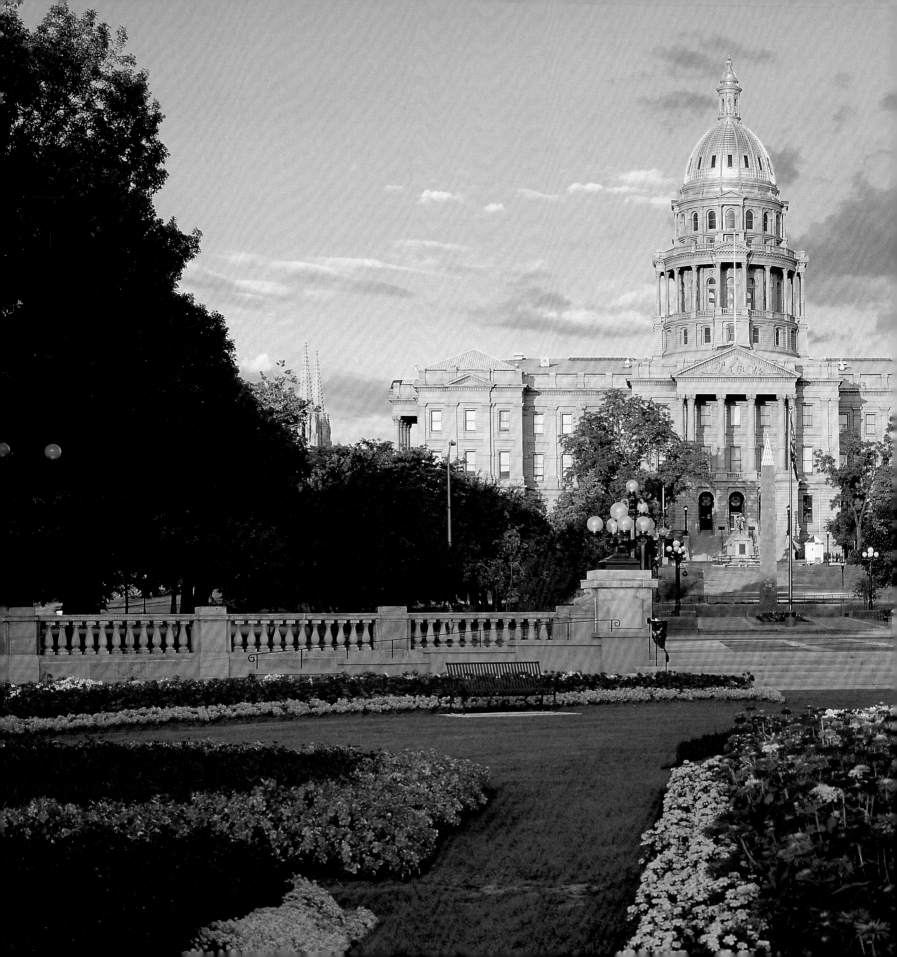

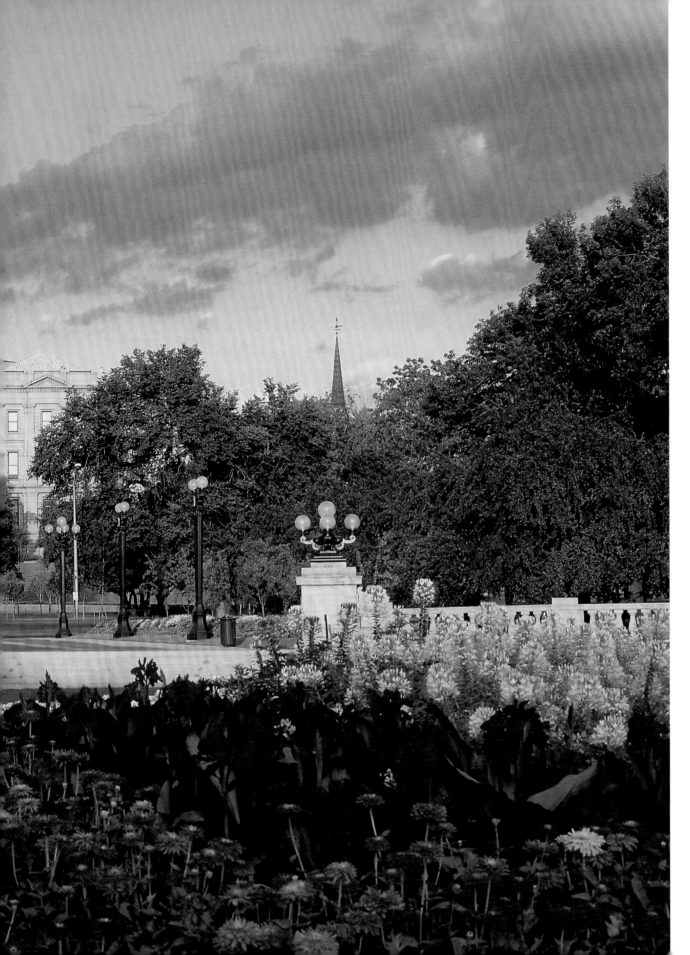

Both the granite and the gold that adorn the State Capitol are native to Colorado. The Capitol was completed in 1908 and the 13th step of the building is said to be exactly one mile above sea level.

45

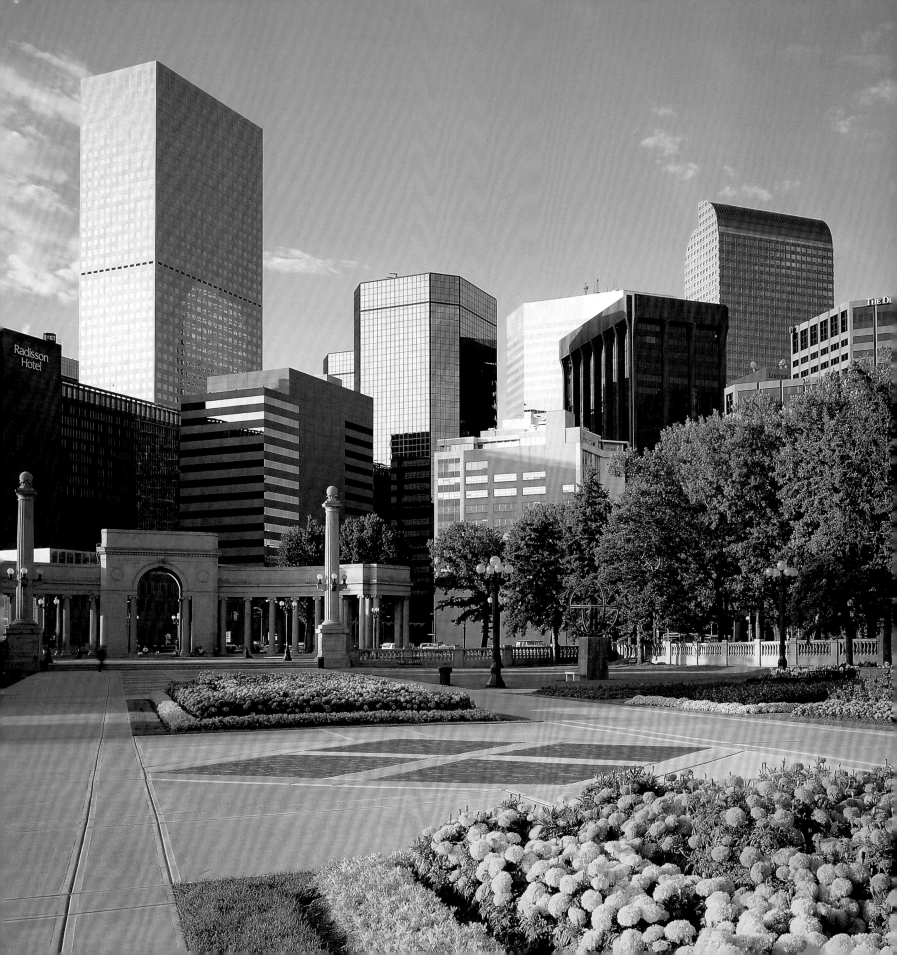

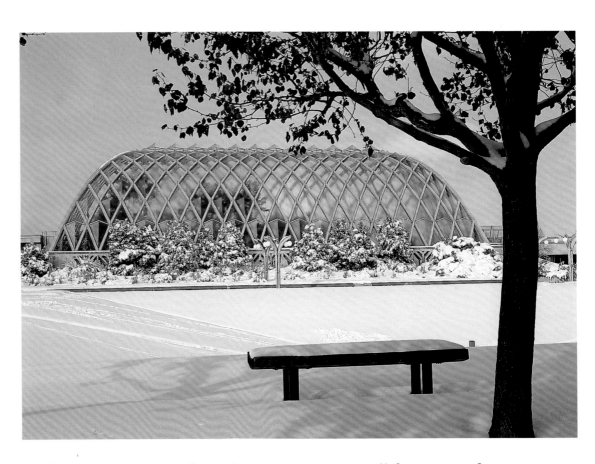

At the Denver Botanical Gardens, guests can stroll from a rainforest to a formal Japanese teahouse, explore an alpine rock garden, or learn about plants mentioned in the Bible—all in an afternoon.

Only 40 percent of Denver's population was born in the city. But who can blame the other 60 percent for moving here? Denver gets more sunshine than Miami and *Fortune* magazine has called it one of the nation's best business cities.

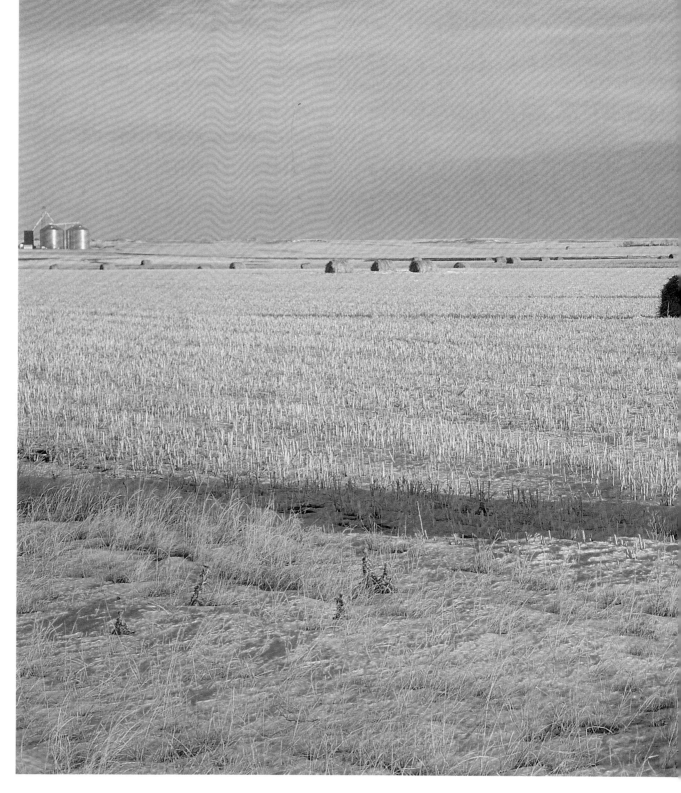

The towering peaks of the Rockies block clouds that move in from the west, creating a rain shadow that stops precipitation from reaching the arid plain to the east. Farmers on that side of the Continental Divide rely on heavy irrigation to operate successfully.

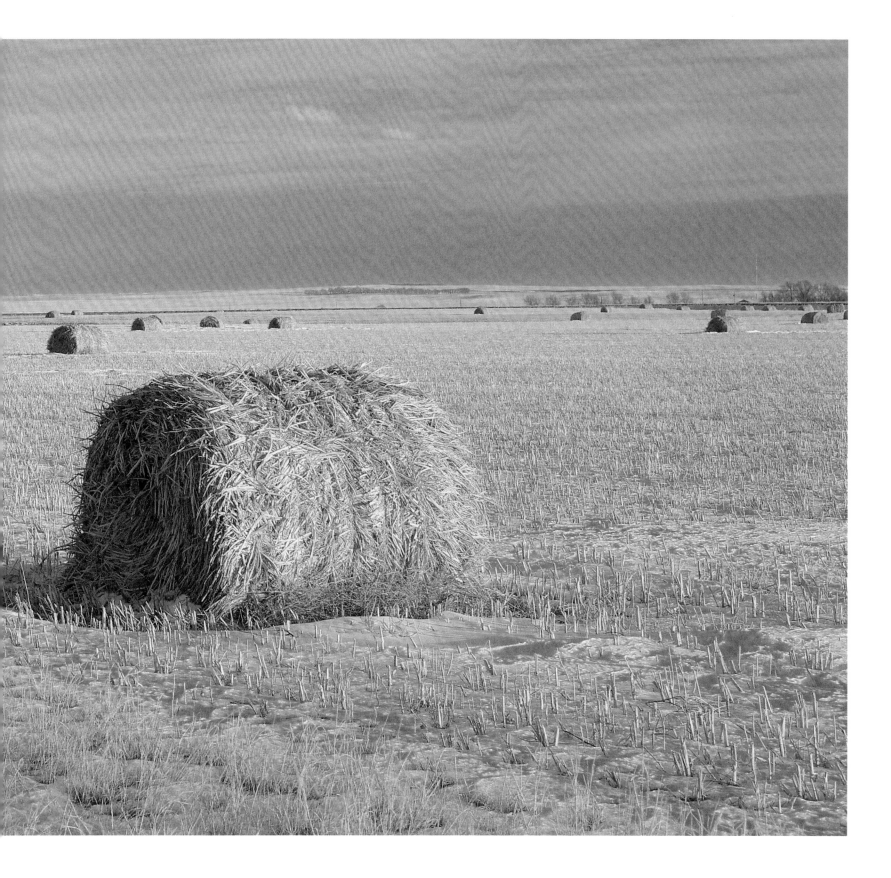

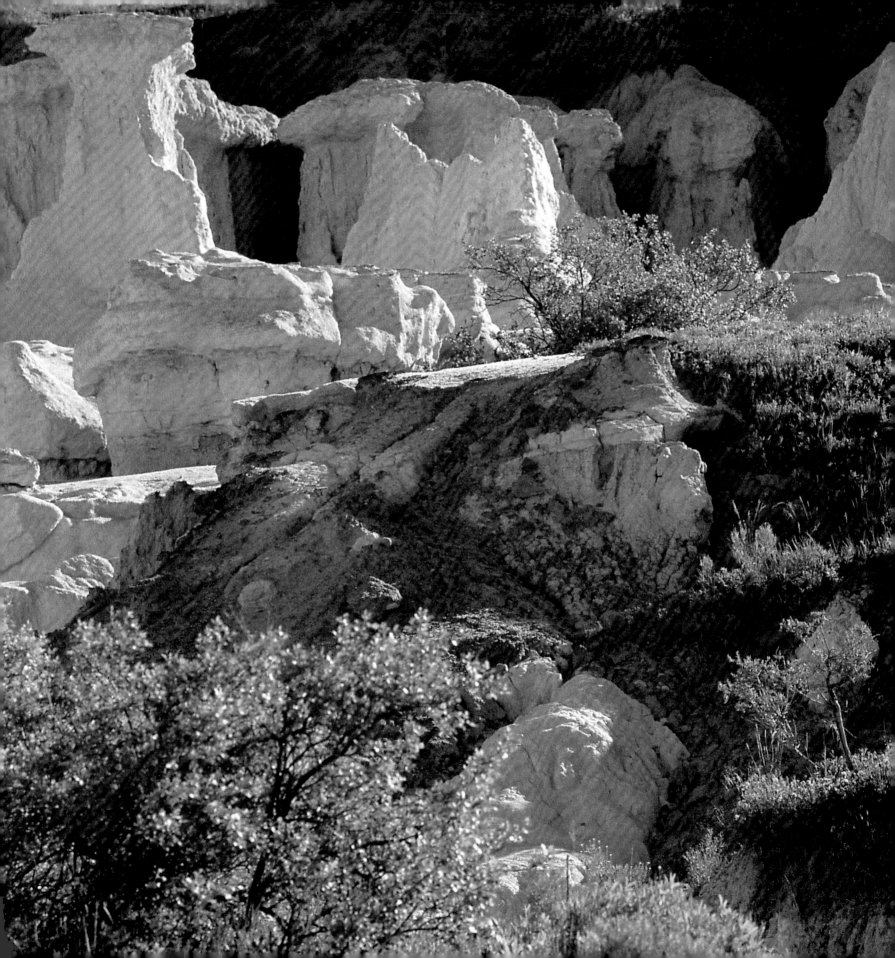

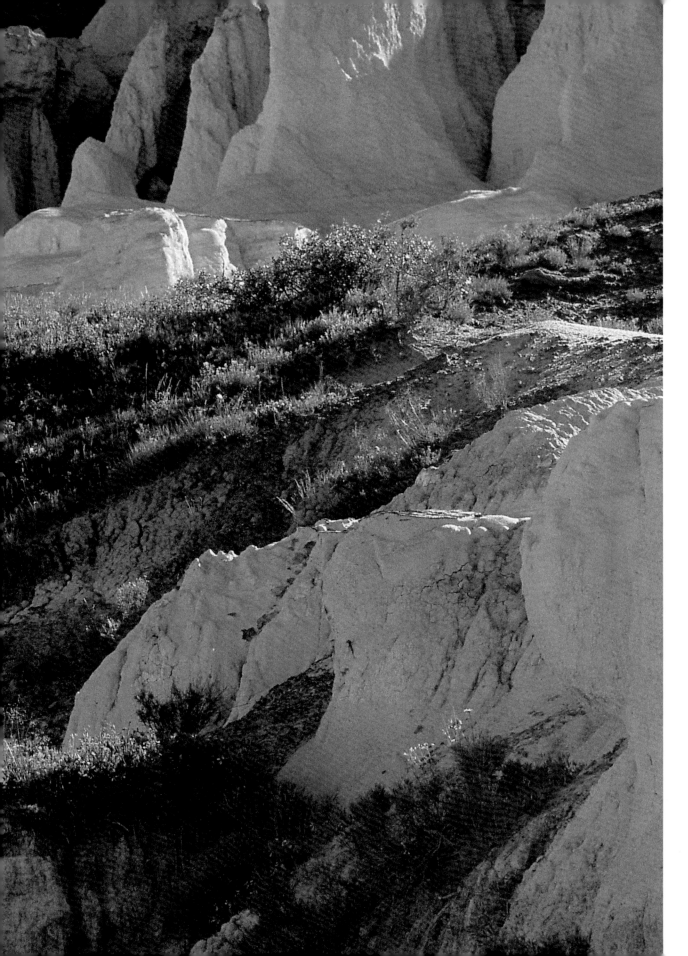

The clay of the Paint Mines, southeast of Calhan, ranges from almost-white to vivid orange. These start-ling colors are created by iron deposits in the earth.

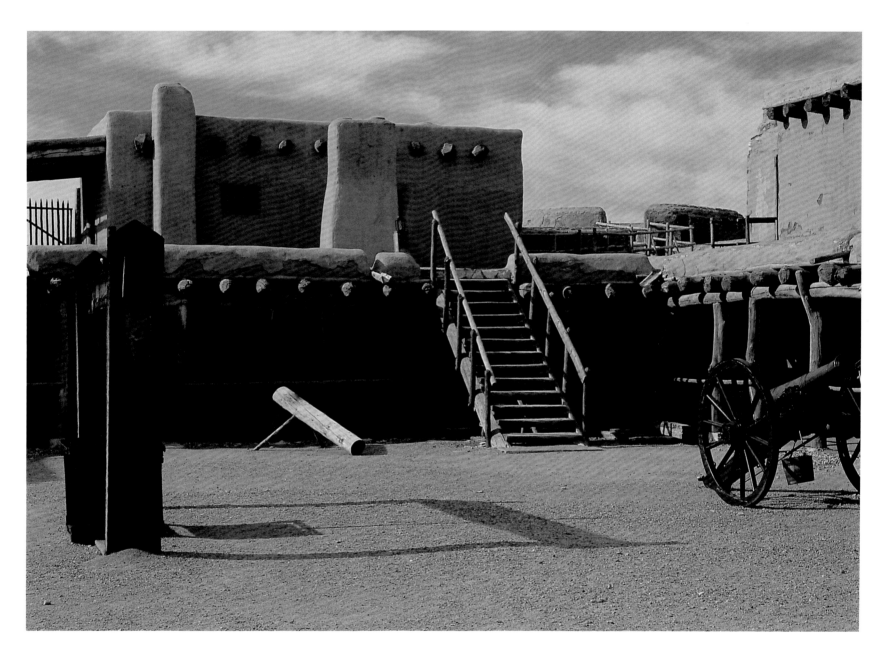

In 1833, Charles and William Bent established a trading post to serve travellers on the fledgling Santa Fe Trail. Today, the reconstructions at Bent's Old Fort National Historic Site commemorate what grew to be one of the most successful ventures of the time.

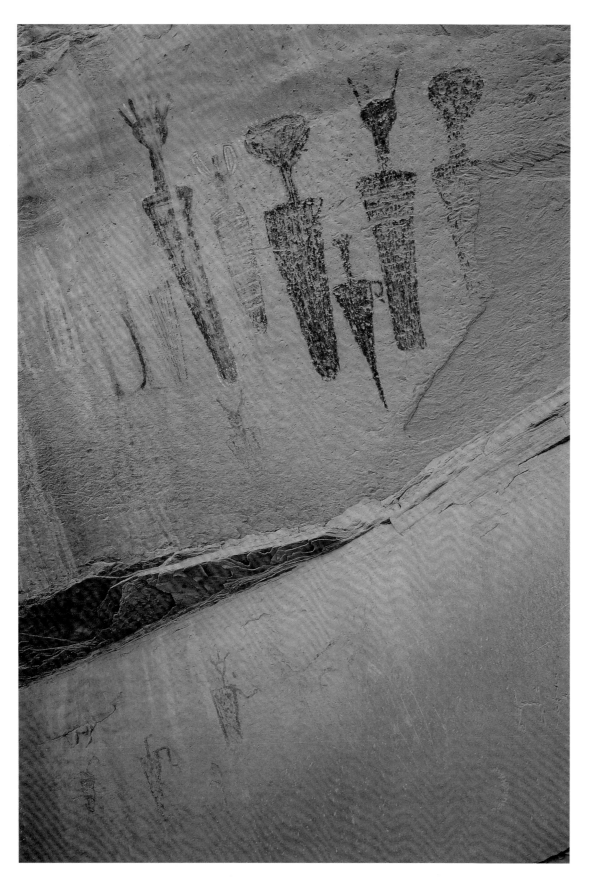

Pictographs have survived for thousands of years in the caves and canyons of Comanche National Grassland. The 420,000-acre area also includes historic ranches, preserved dinosaur tracks, and an array of recreation trails.

The Pawnee Buttes
have withstood
hundreds of years
of wind and rain,
rising 300 feet from
the surrounding
grasslands. Once the
sprawling domain of
a cattle baron, these
grasslands have been
slowly restored to
serve as a wildlife
habitat and recre-
ation area.

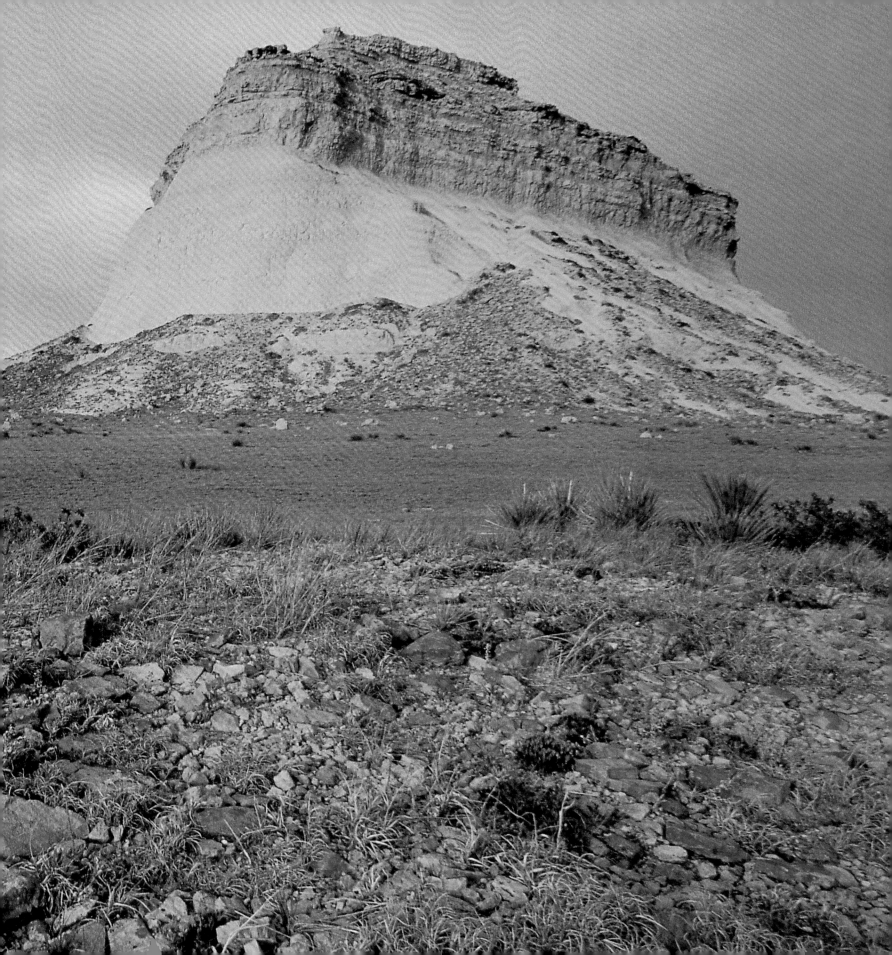

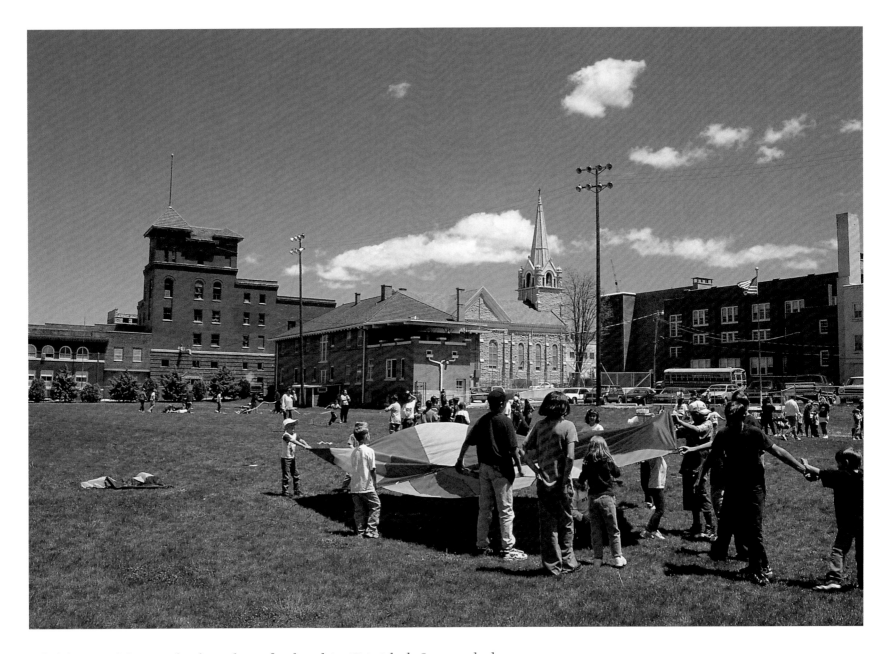

Children celebrate the last day of school in Trinidad. Located along the historic Santa Fe Trail, Trinidad was once a stopping place for hopeful pioneers on their way to New Mexico.

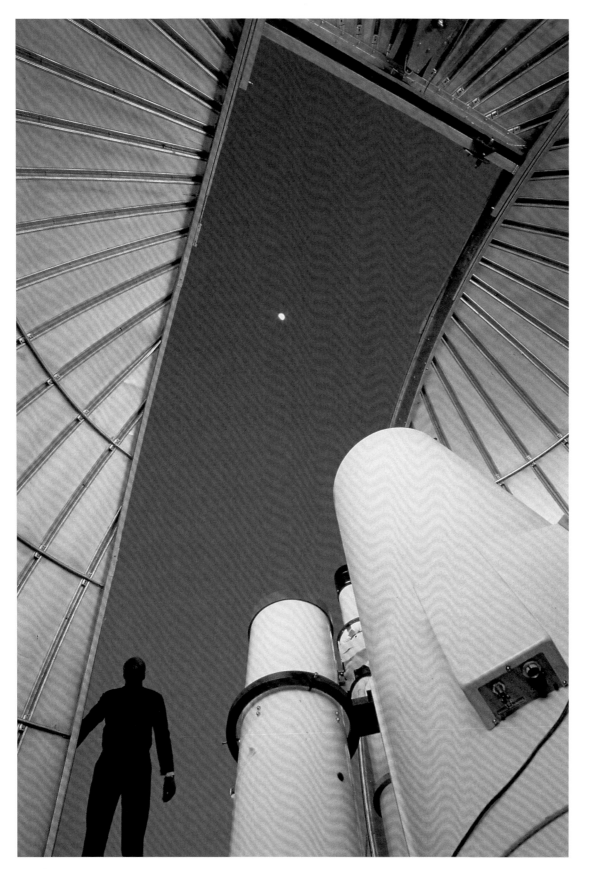

This state-of-the-art observatory is part of Peterson Air Force Base in Colorado Springs. The base is home to the United States Space Command and the North American Aerospace Defence Command.

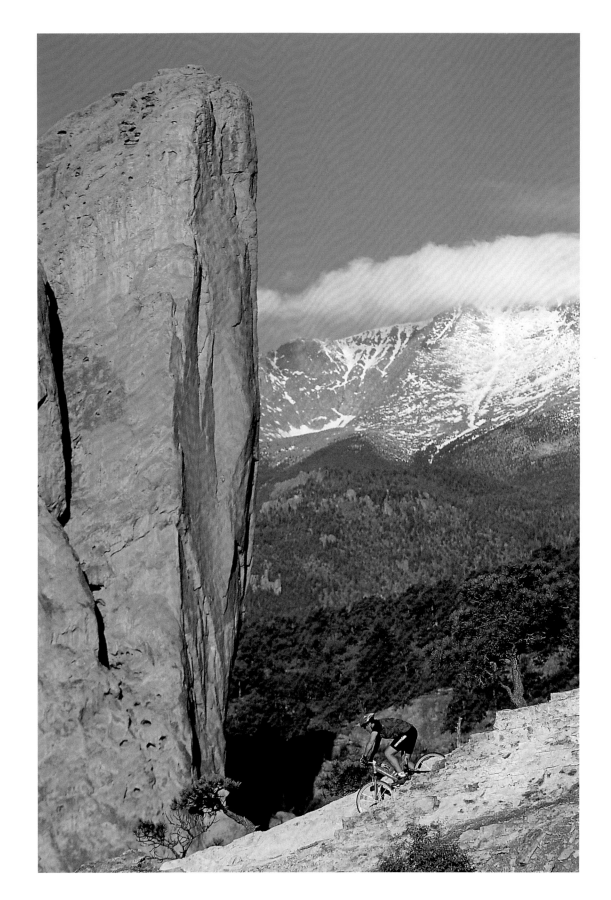

An array of mountain biking trails, from novice to expert, surrounds Colorado Springs. As well as weekend bikers and hikers, this area hosts elite-level athletes from around the nation, drawn by the opportunities offered by the nearby US Olympic Complex.

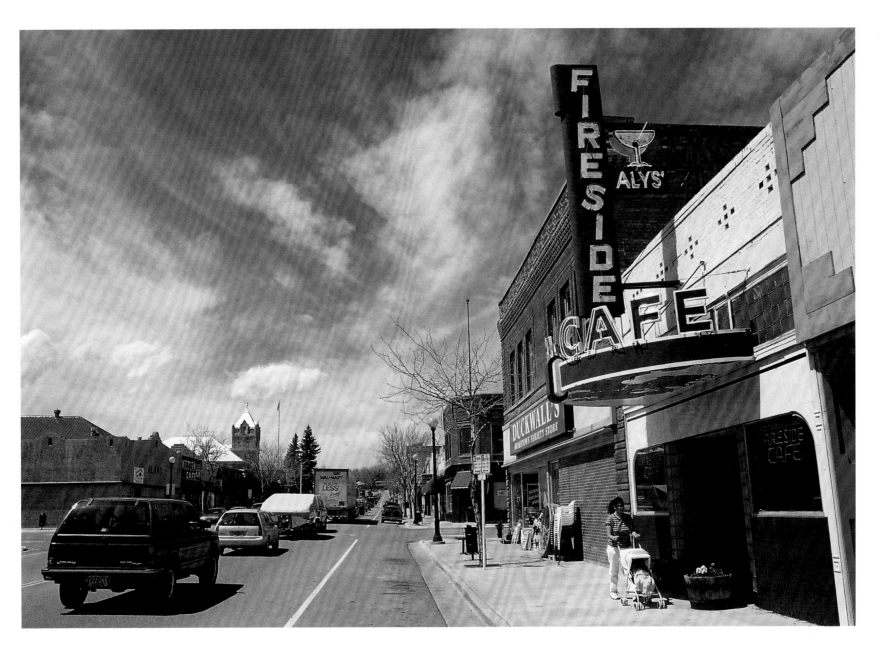

In the early 1900s, the small community of Walsenburg was one of Colorado's foremost producers of coal. The community's mining museum is still a favorite stop for visitors.

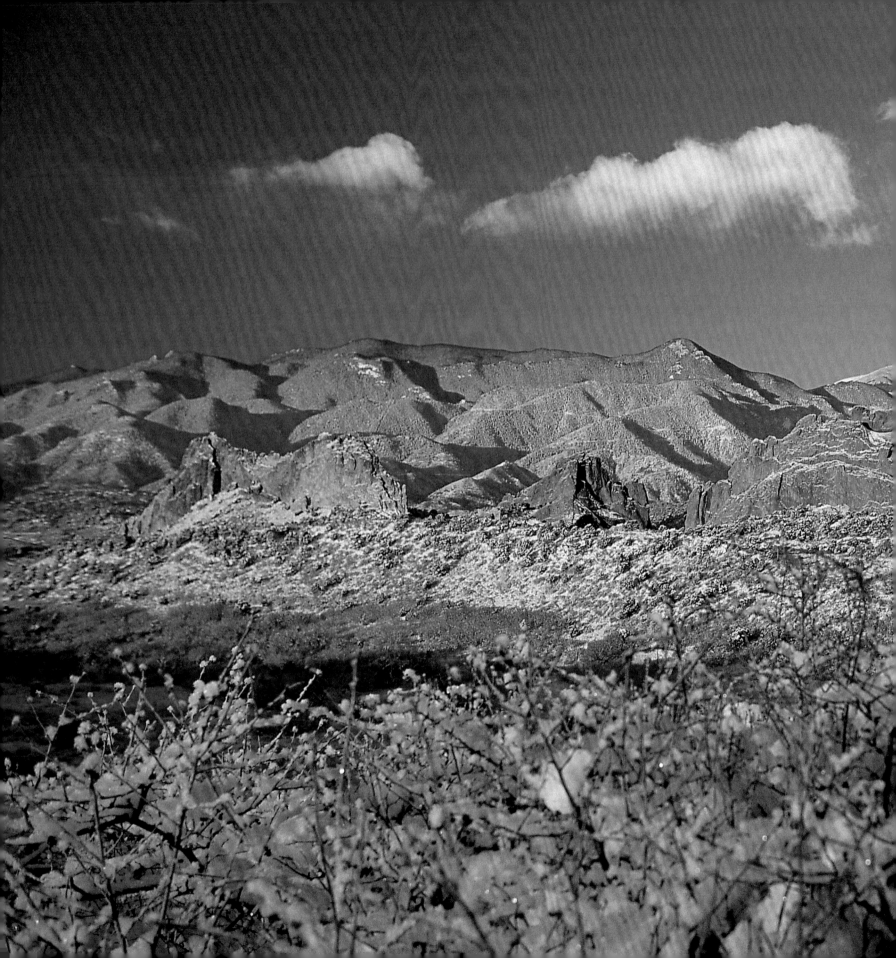

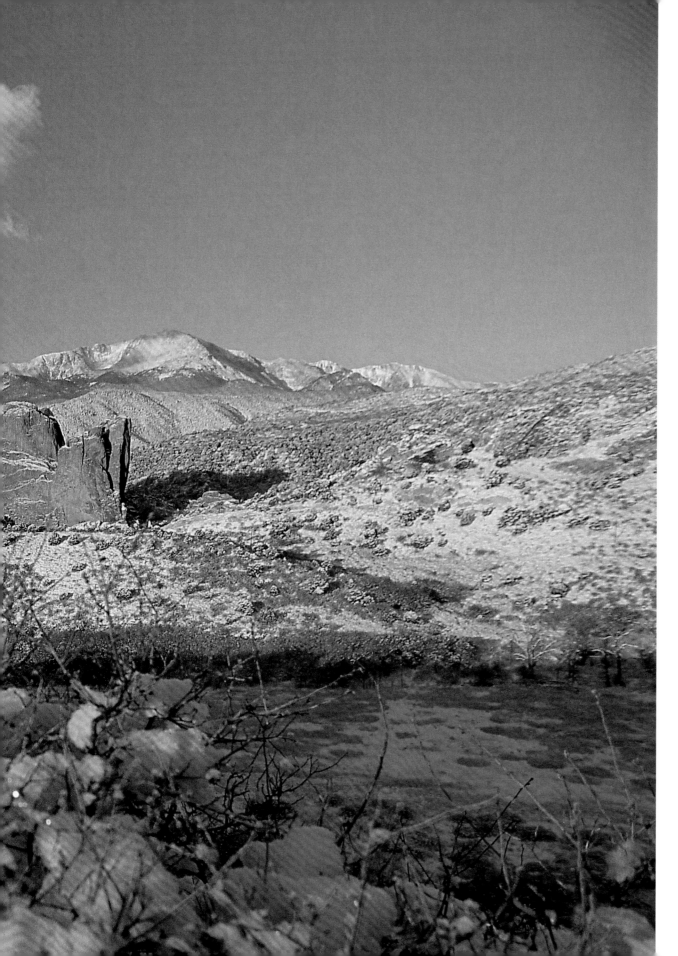

Encompassing more than 1,300 acres, the Garden of the Gods offers some of the state's most unique terrain. Red sandstone formations stand against the backdrop of Pikes Peak, 14,100 feet high.

Since the mid-1800s, people have flocked to Manitou Springs, first for the reputedly healing waters of the mineral springs and now for the community's historic and geographic attractions. These include the Cave of the Winds, the Manitou Cliff Dwellings Museum, and Pikes Peak Cog Railway.

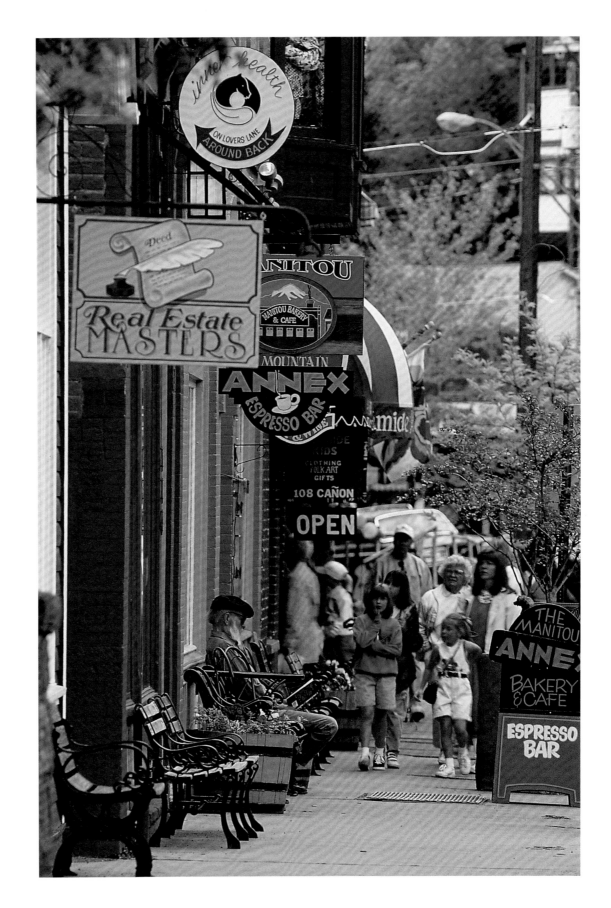

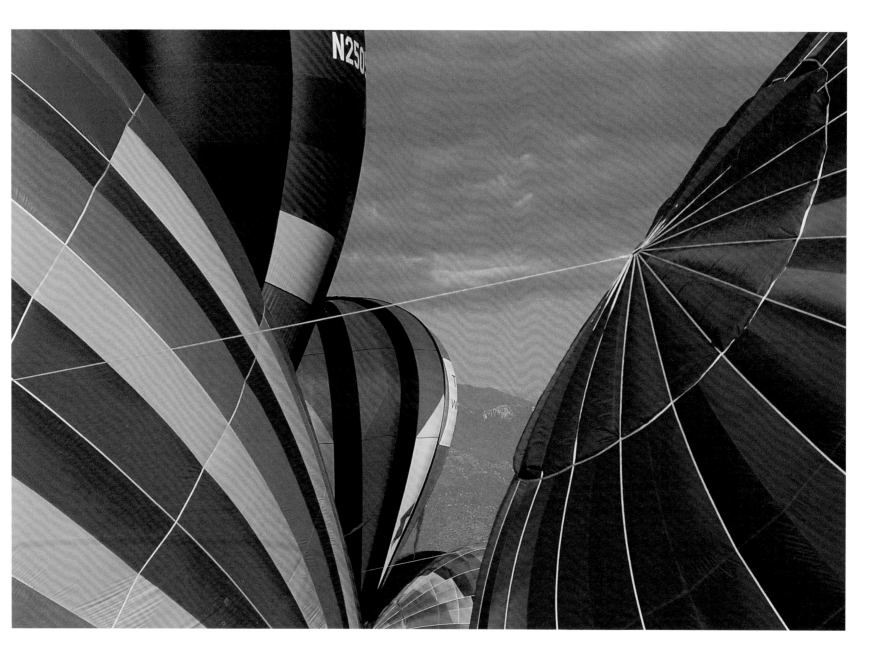

Hot-air balloons crowd the grounds at Colorado Springs' Memorial Park as more than a hundred enthusiasts prepare to participate in the annual International Balloon Classic.

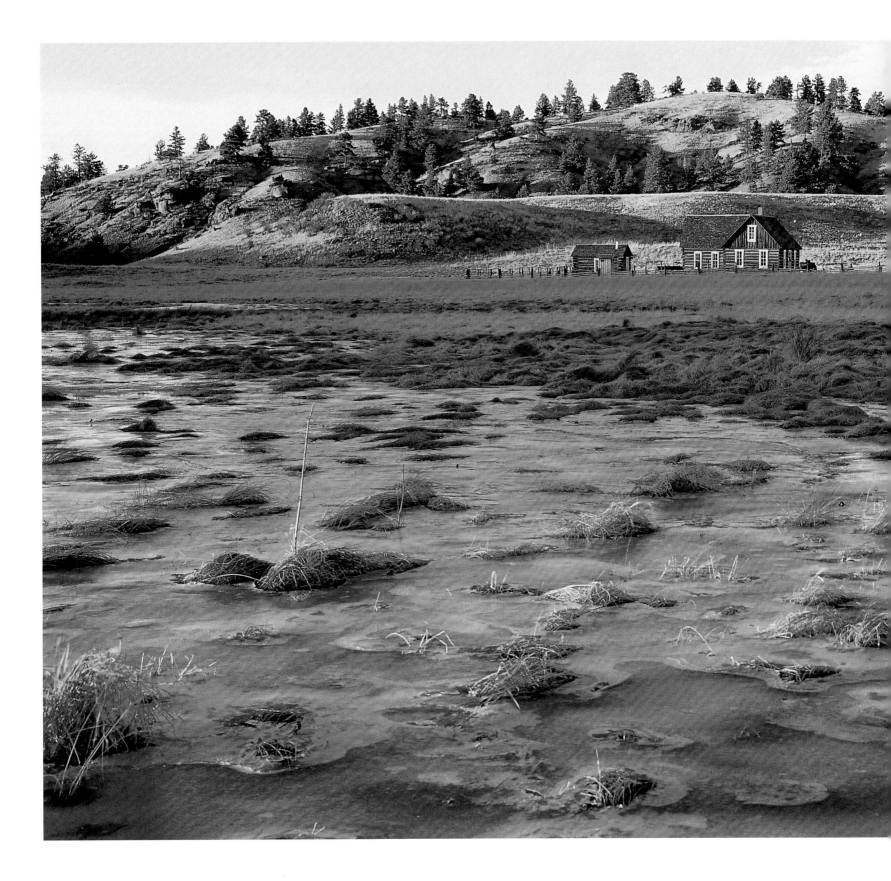

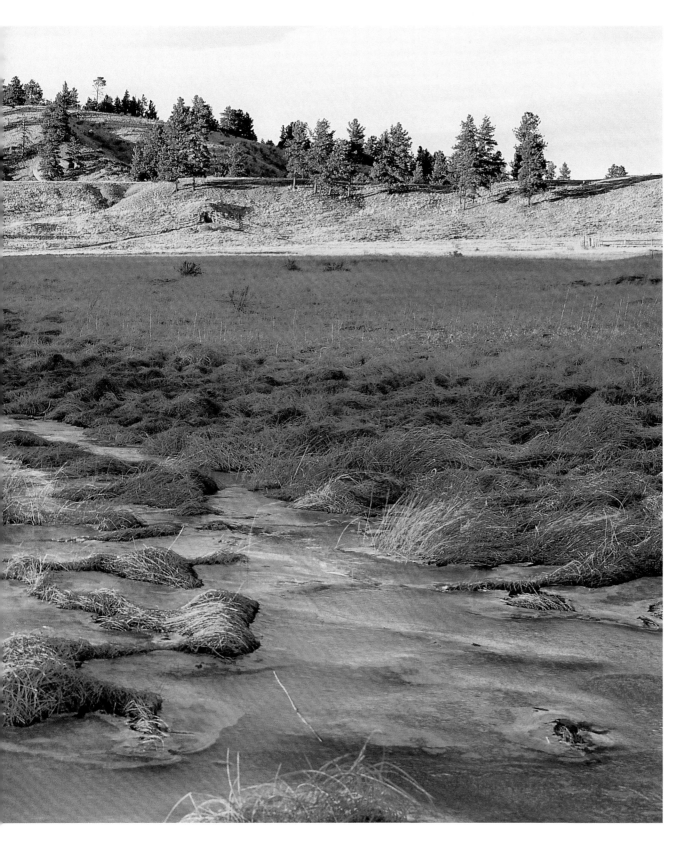

About 35 million years ago, an eruption blanketed this landscape with volcanic dust, preserving an amazing array of plants, fish, birds, and mammals. Today, Florissant Fossil Beds National Monument protects the petrified remains of an ancient lake and sequoia forest.

65

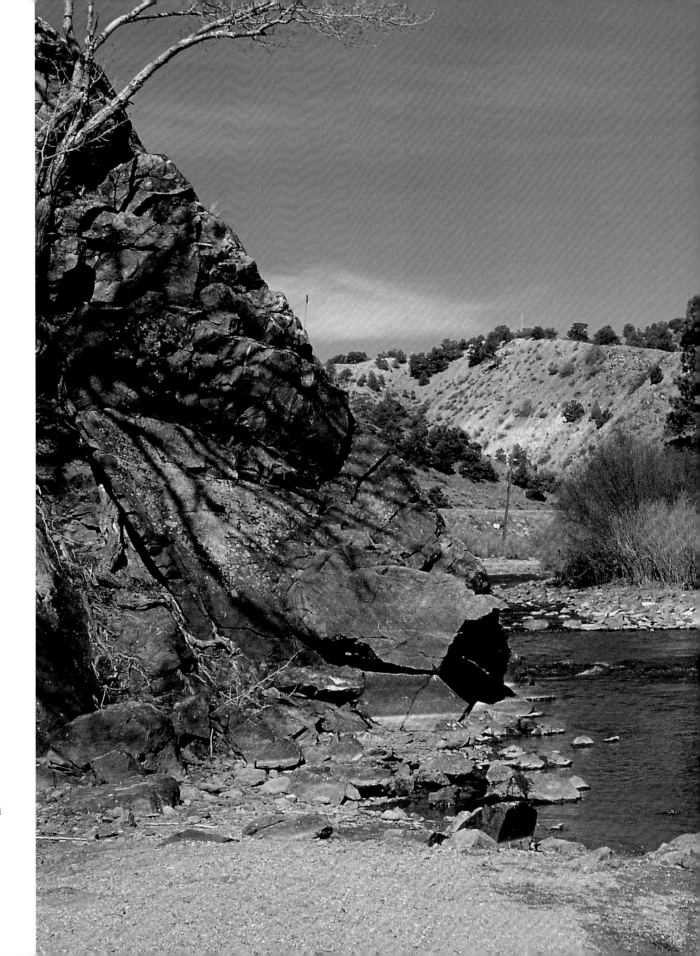

An angler waits
patiently for trout in
the Arkansas River
near Salida.

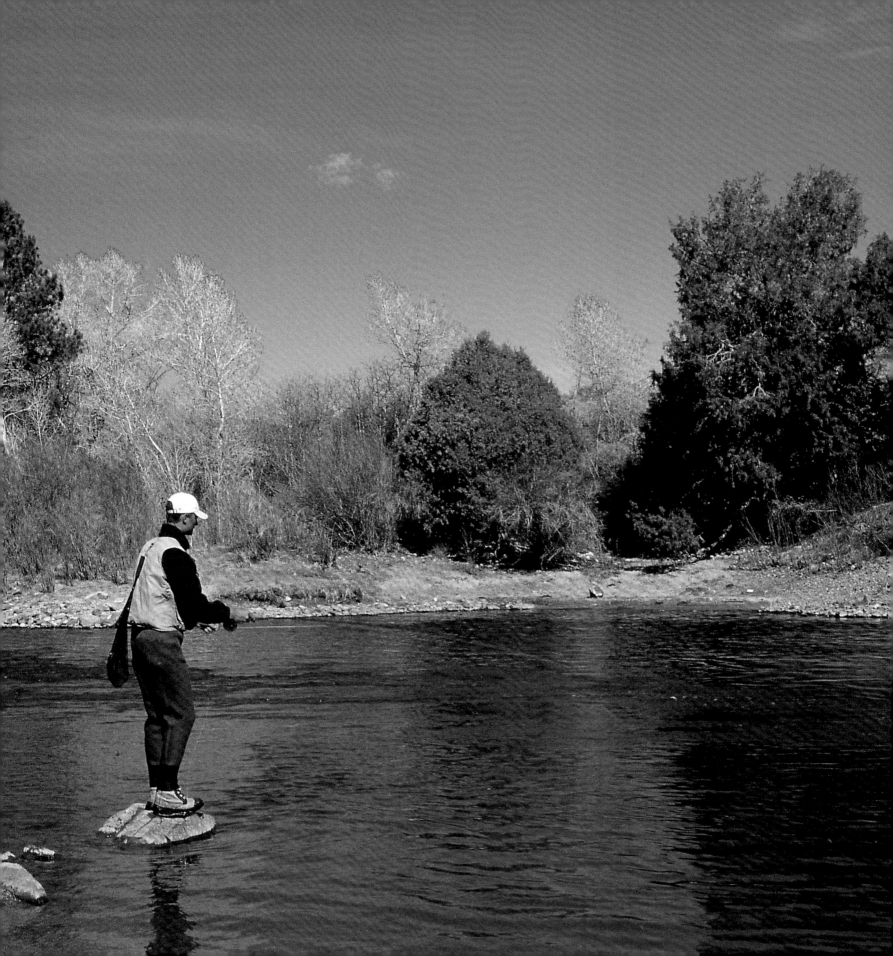

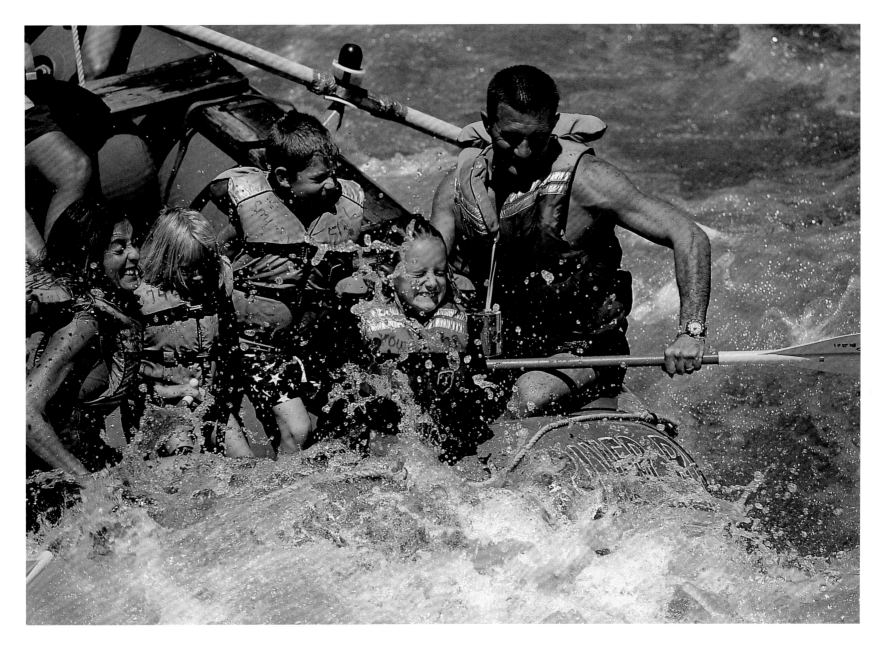

The Arkansas River is one of the most popular whitewater rafting destinations on the continent. More than 300,000 people float down the state's rivers each year, by raft, kayak, canoe, or inner tube.

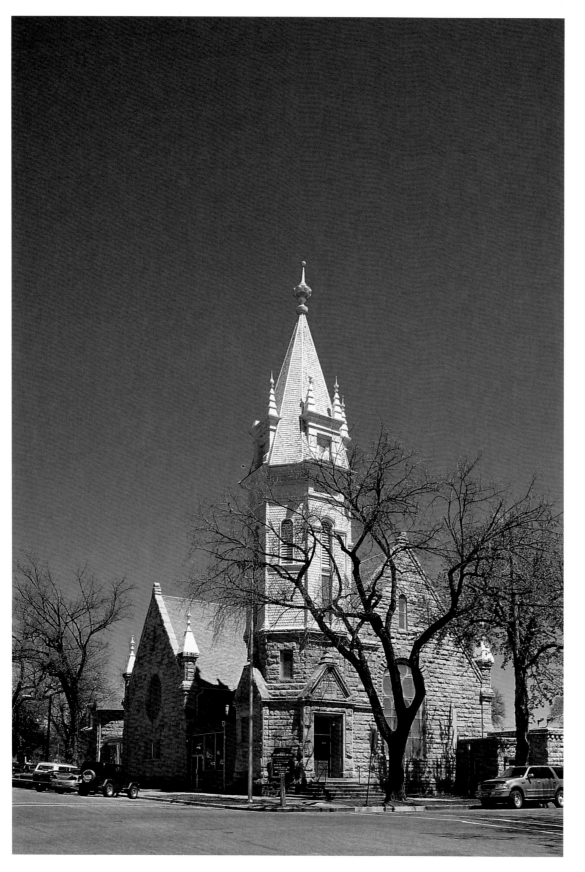

The United Presbyterian Church stands on a picturesque corner in Cañon City. Like many Colorado communities, this was once a gold rush town. Today, it is better known for nearby recreation opportunities, from fishing and golf to biking and kayaking.

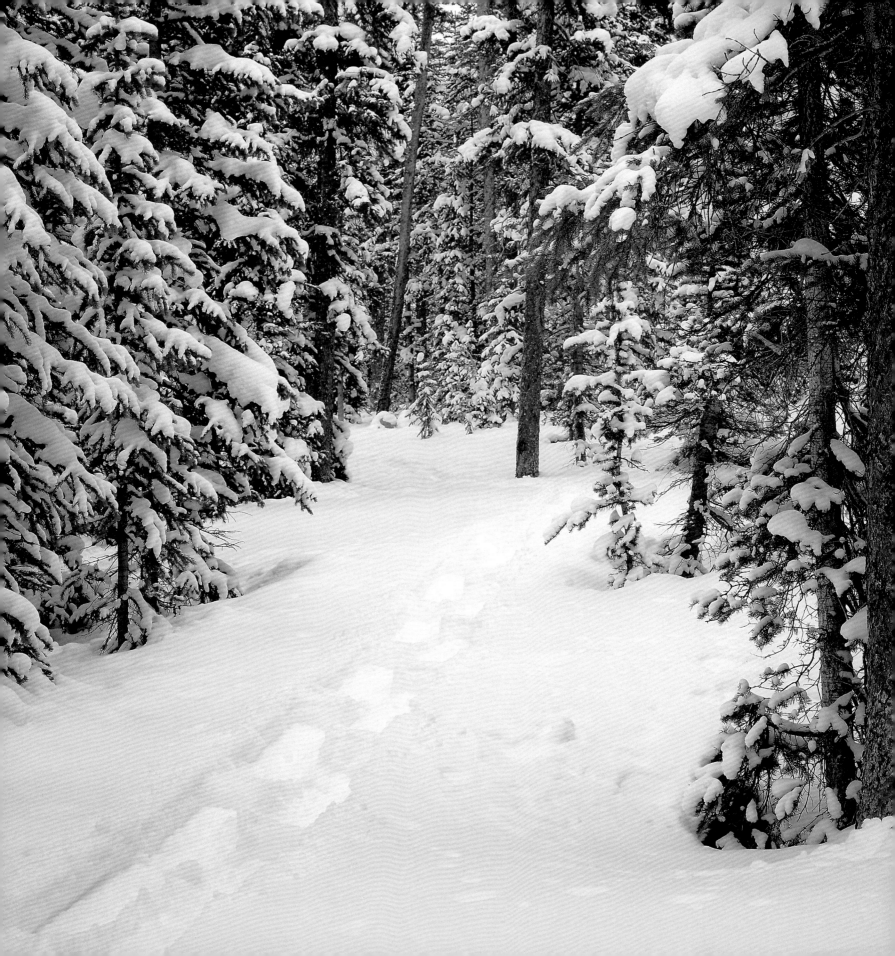

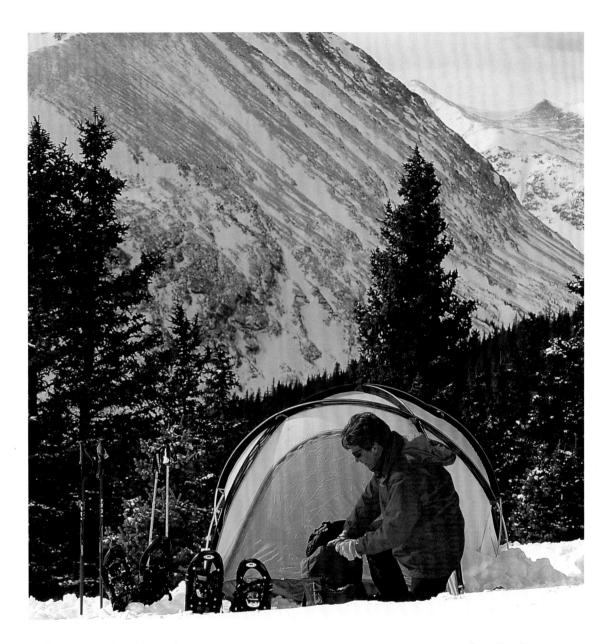

Fifty-two of Colorado's mountains tower more than 14,000 feet high, drawing hikers, rock climbers, and mountaineers from around the world.

Snowshoers have left tracks through the pine trees in San Isabel National Forest, which encompasses part of the Sangre de Cristo Mountains and the well-known Spanish Peaks.

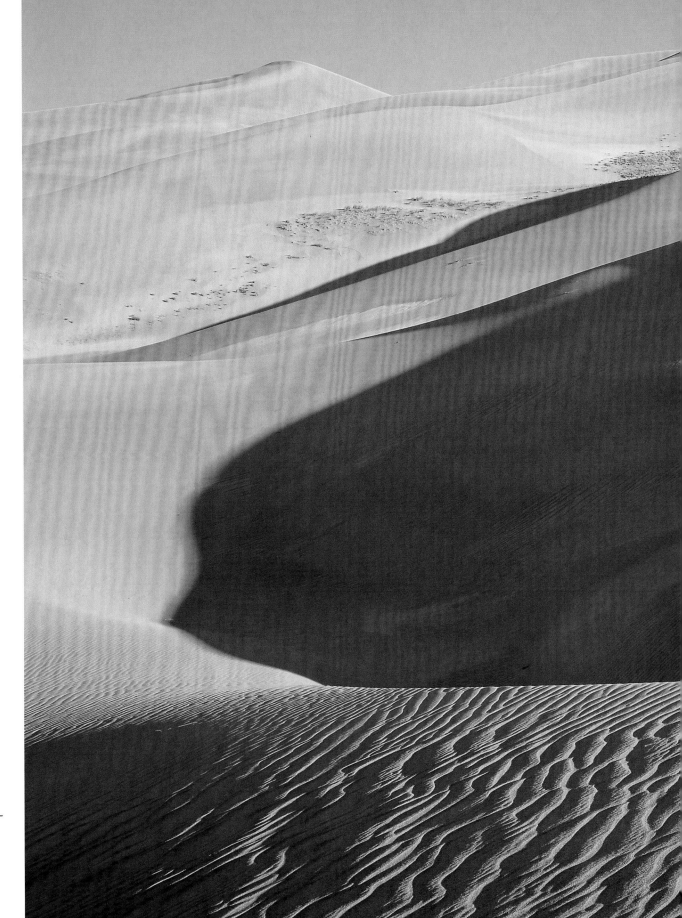

Over thousands of years, the wind—blocked by the Sangre de Cristo Mountains—has deposited sand at what is now the Great Sand Dunes National Monument. The desertlike landscape draws hikers and campers throughout the summer.

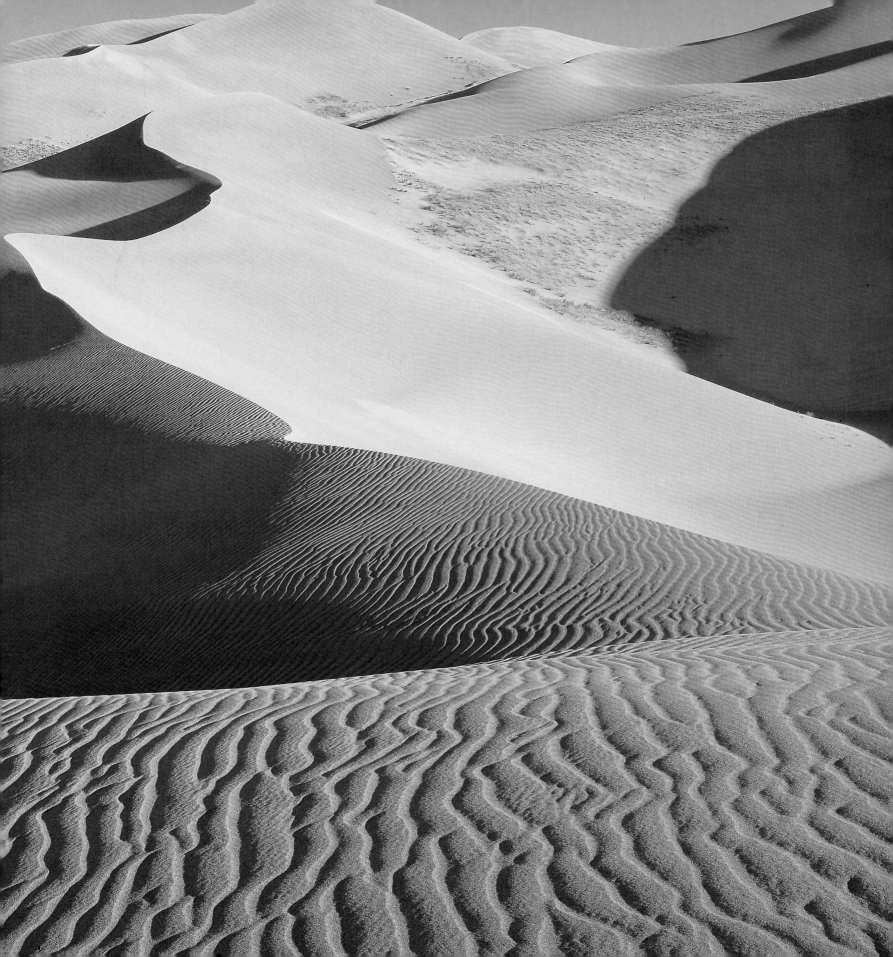

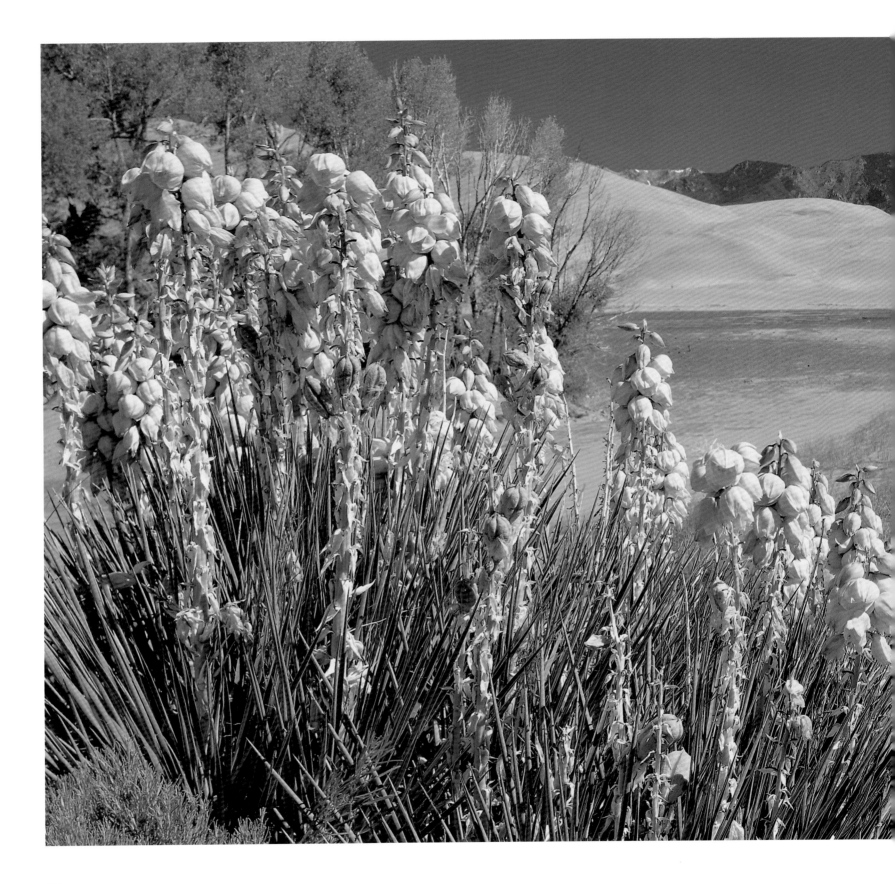

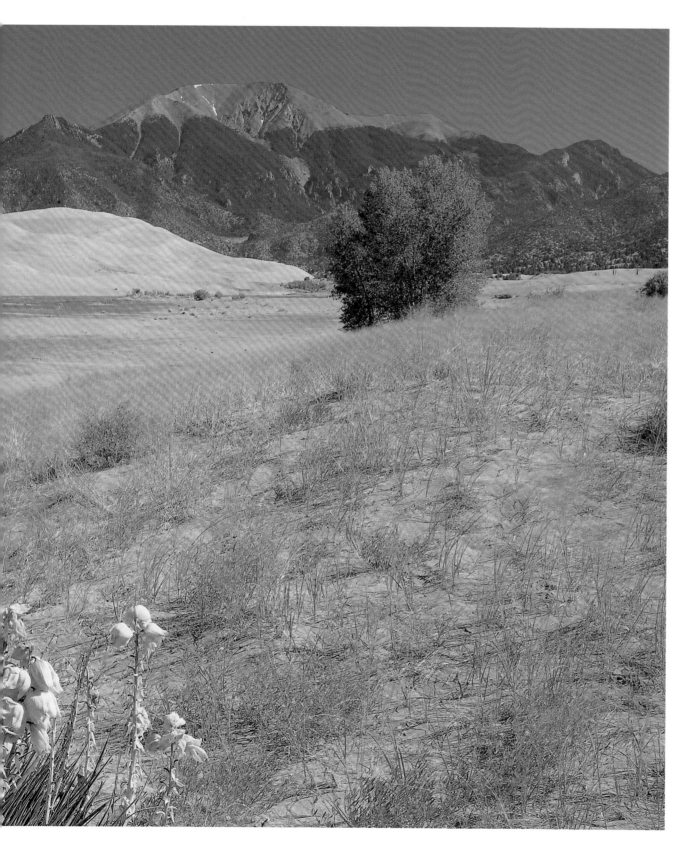

Reaching up to 900 feet high, these are the nation's largest dunes. They were declared a national monument in 1932 after intense lobbying by local residents.

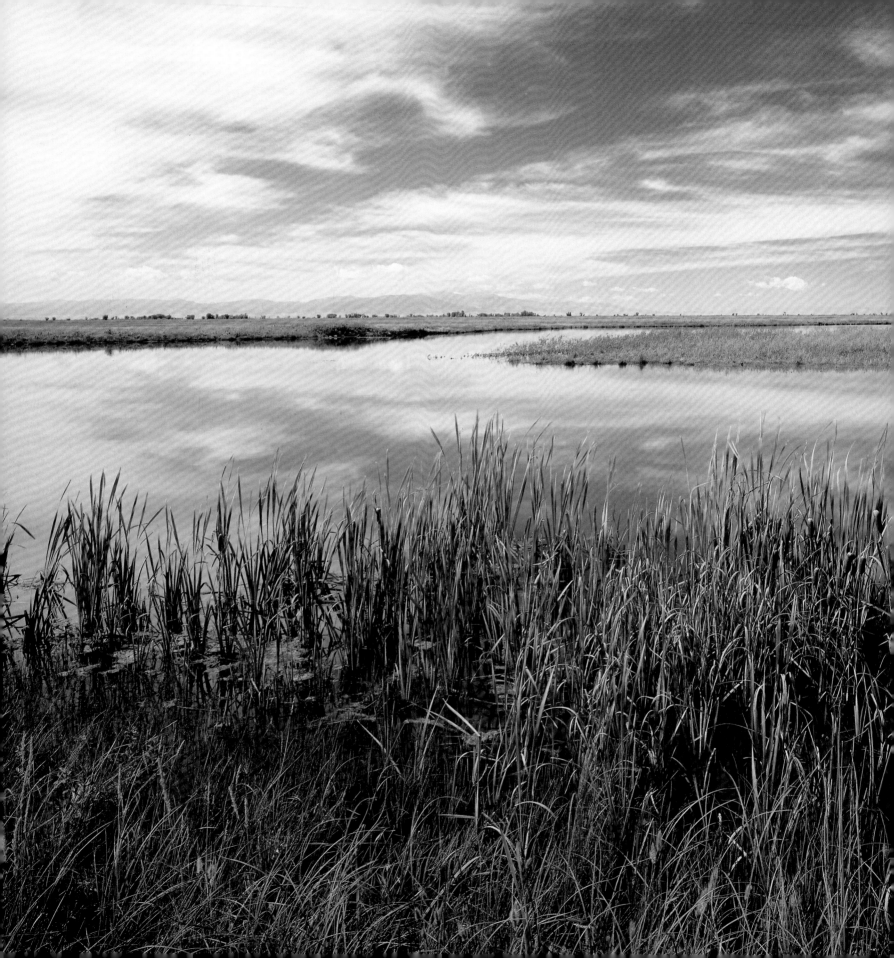

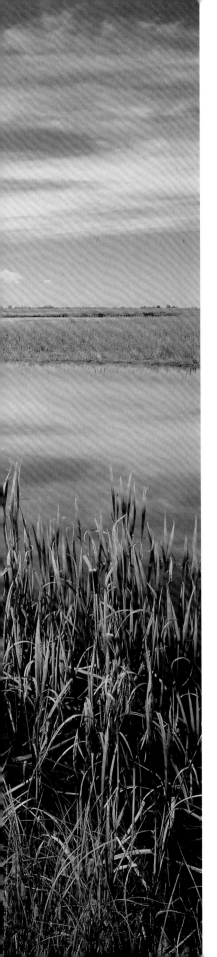

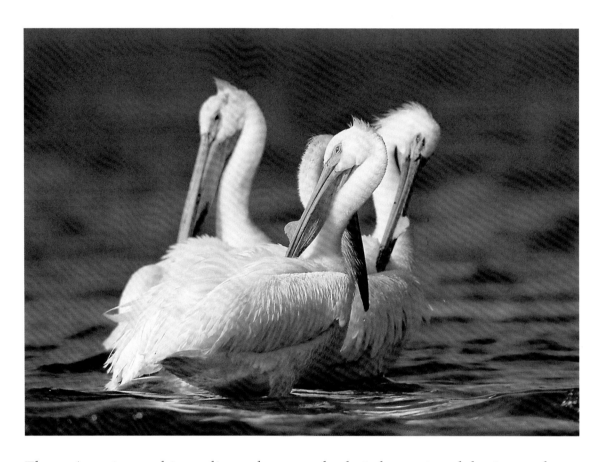

These American white pelicans have made their home in a lake in southern Colorado. The pelicans rear their chicks in their northern range, which stretches from Canada to the Gulf Coast, then head south for the winter.

Home to whooping cranes, sandhill cranes, wintering hawks and bald eagles, and dozens of other avian species, Alamosa National Wildlife Refuge is a paradise for birdwatchers.

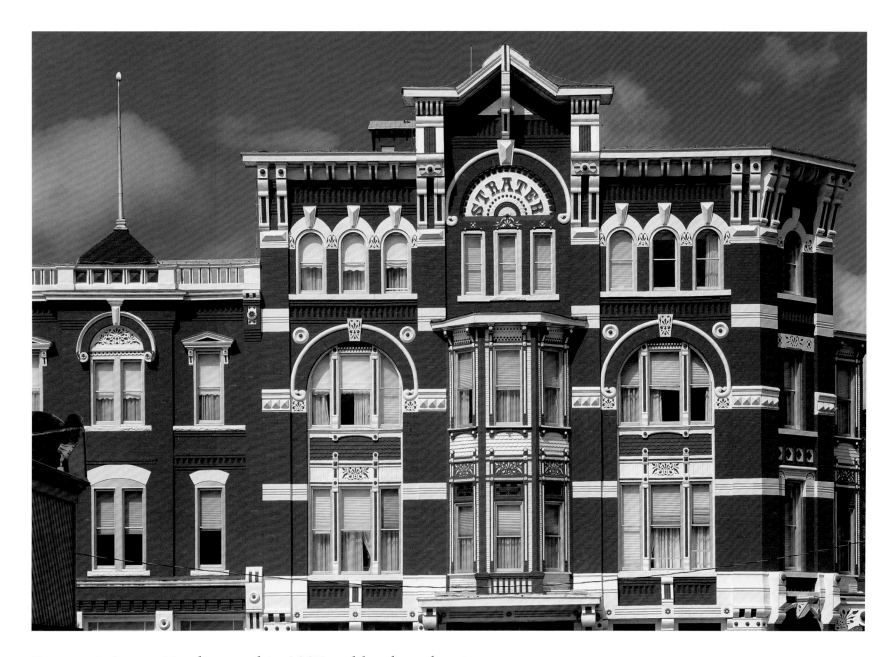

Durango's Strater Hotel opened in 1887 and has been hosting visitors ever since. The antique-filled rooms remind guests of the boomtown days when entrepreneur Henry H. Strater built the hotel.

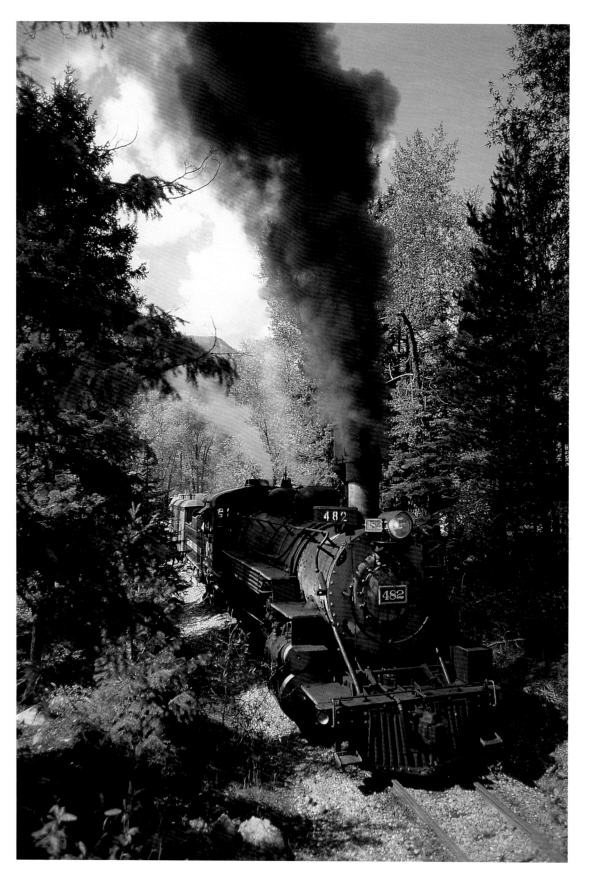

The Durango and Silverton Narrow-Gauge Railroad offers a breathtaking journey along the Animas River Canyon. Over 200,000 people take the trip each year.

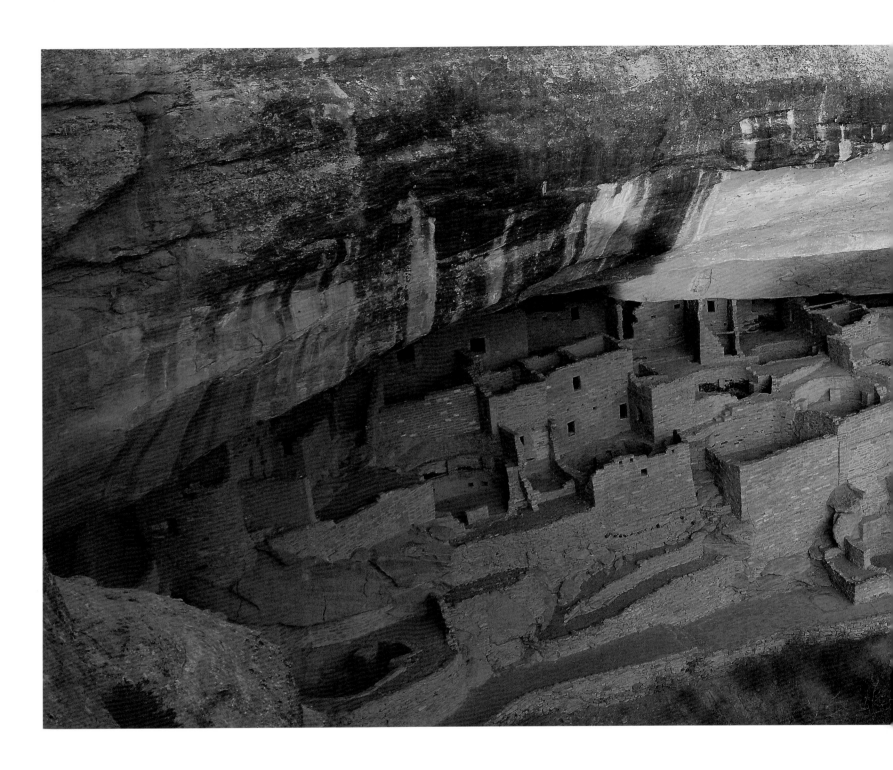

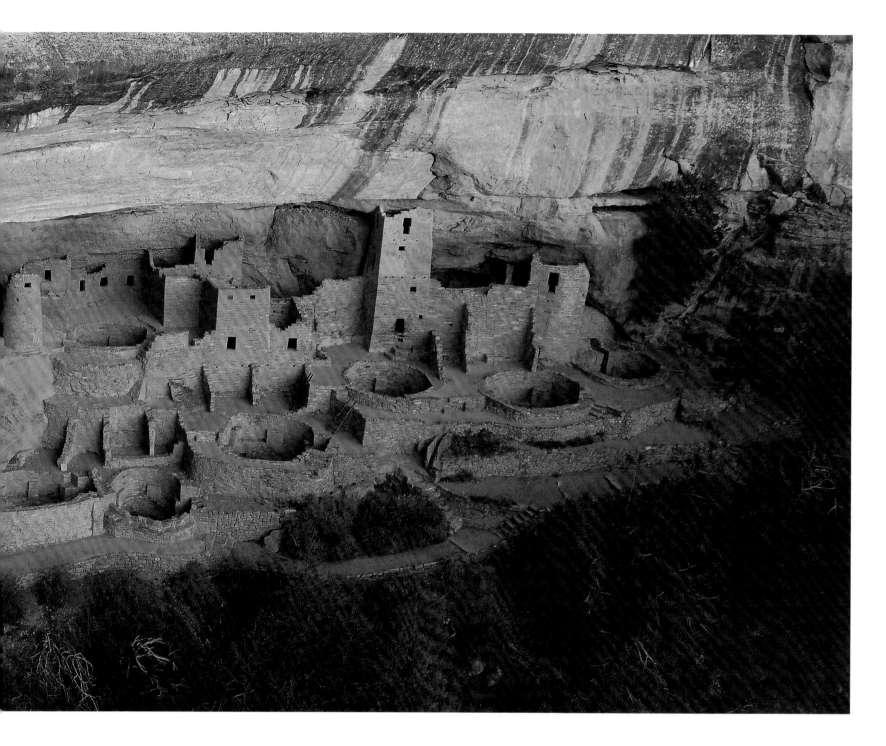

Voted the world's best historic monument by readers of *Conde Nast Traveler*, Mesa Verde National Park preserves the distinctive cliff dwellings of the ancient Puebloan people, dating to before A.D. 1300.

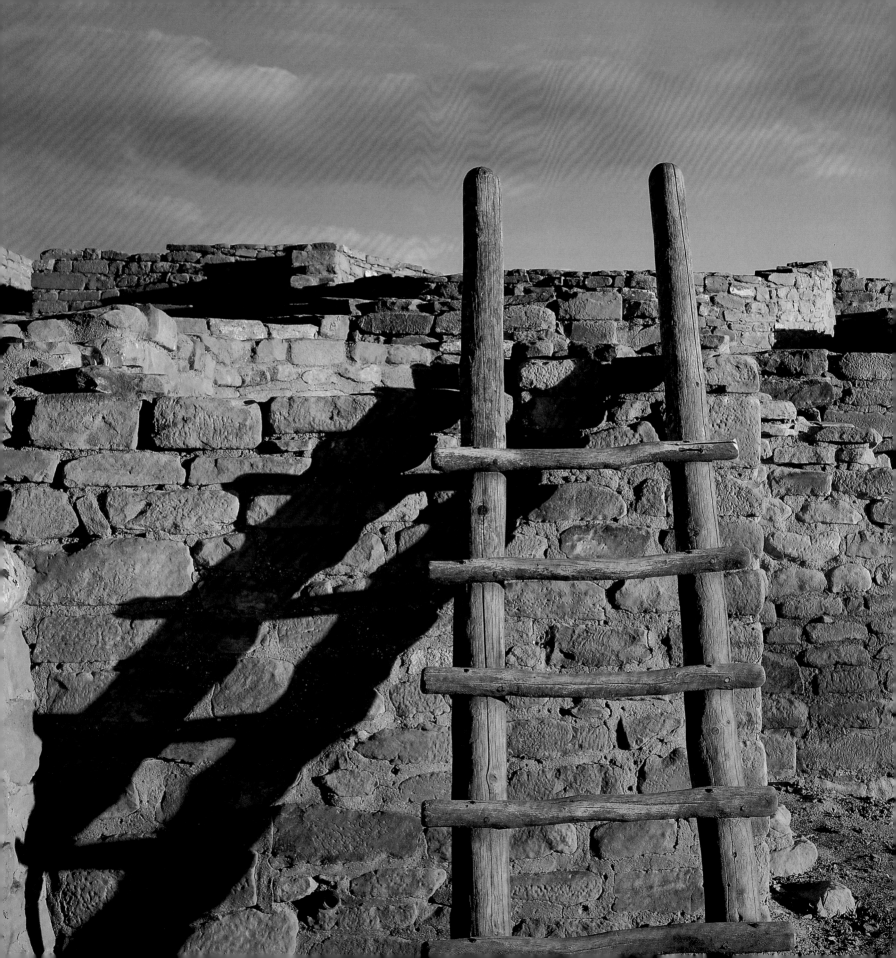

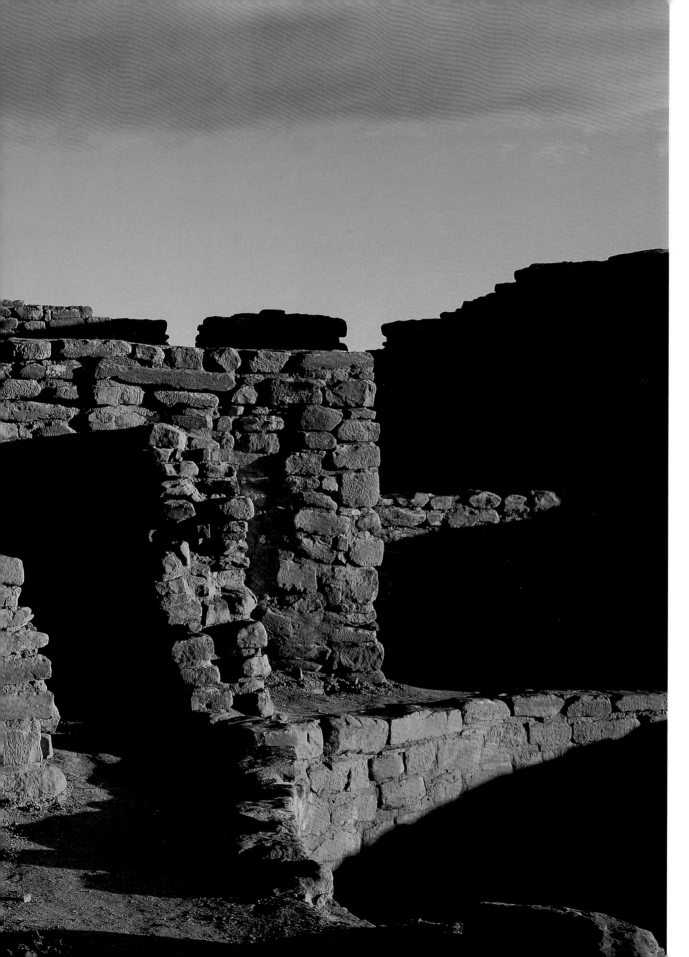

Two local ranchers were searching for stray cattle in 1888 when they stumbled upon the ruins at Mesa Verde. Archeologists and visitors soon flocked to the site, which was declared a national park in 1906.

83

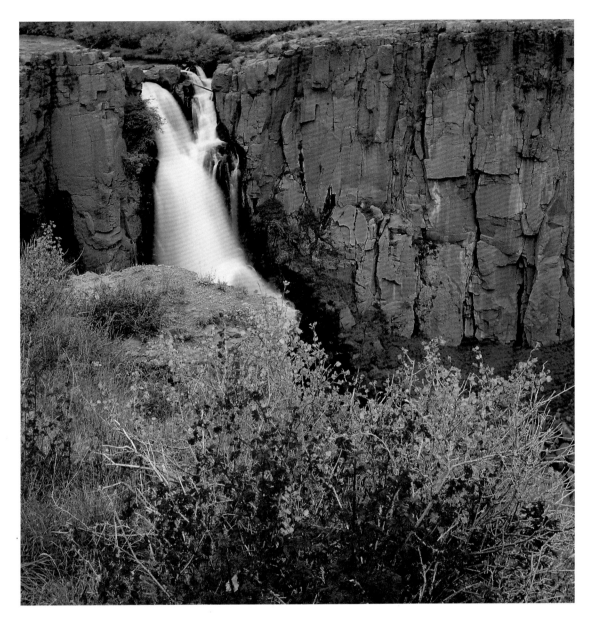

Clear Creek Falls cascades down a rocky bluff near Creede, in the Rio Grande National Forest. Much of this two-million-acre wilderness is accessible only to backpackers or horseback riders.

Only 1,200 feet apart in places—40 feet apart at the base—the walls of the Black Canyon of the Gunnison tower half a mile high. The Gunnison River has sliced this gorge through layers of soft volcanic rock, remnants of ancient eruptions.

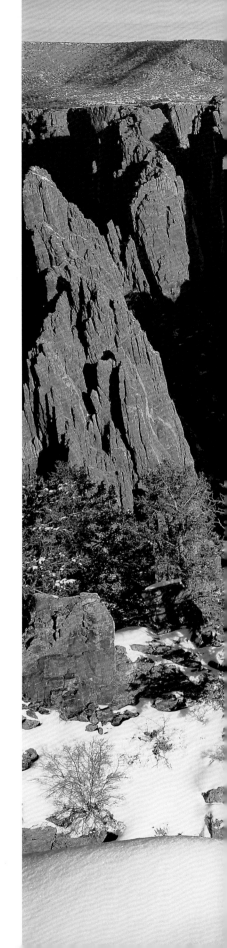

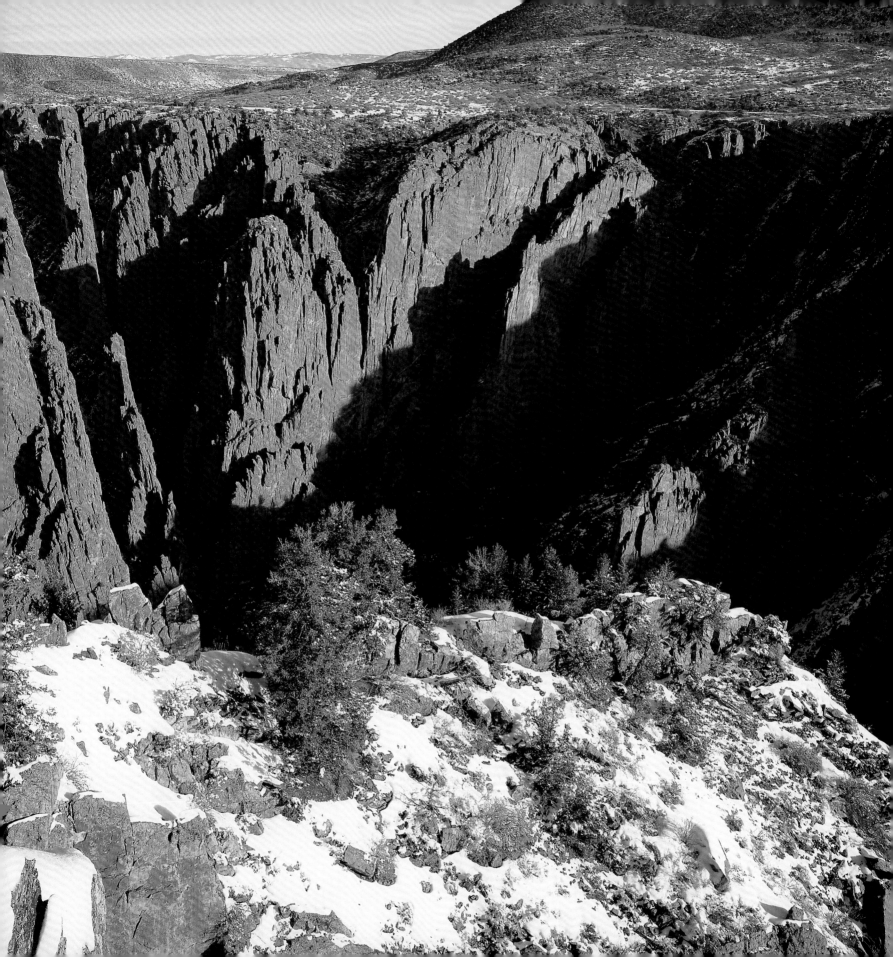

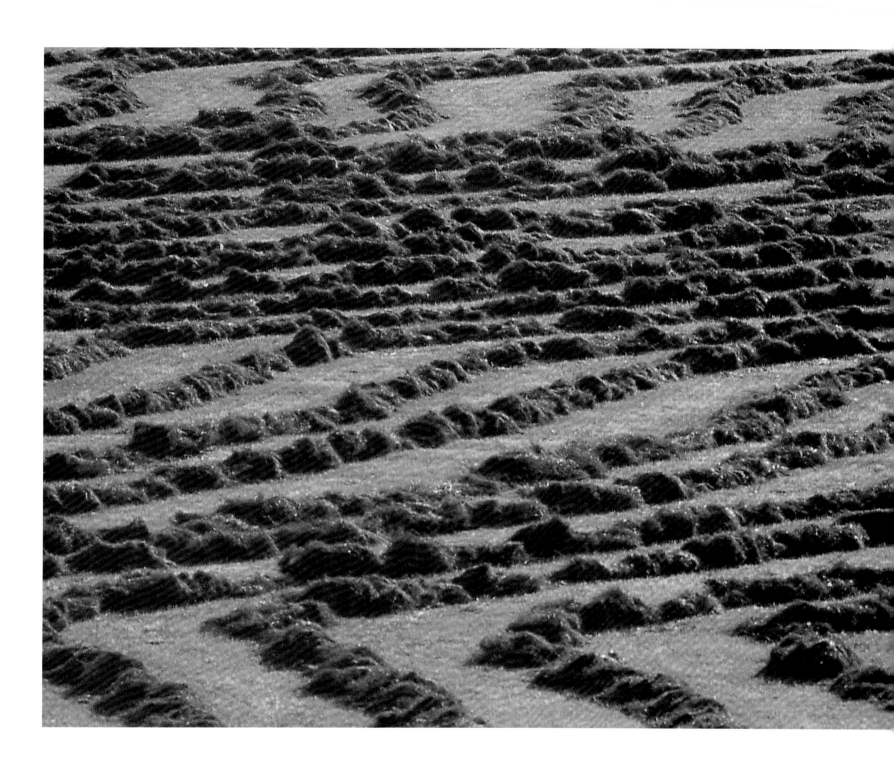

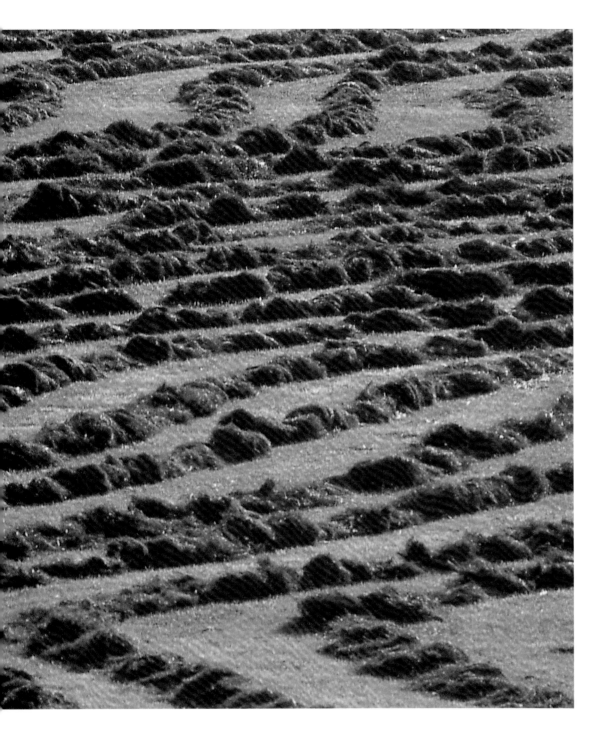

Colorado's farmers harvest almost
1,500 acres of hay each year. The
state's other principal crops
include wheat, corn, sorghum,
barley, oats, and rye.

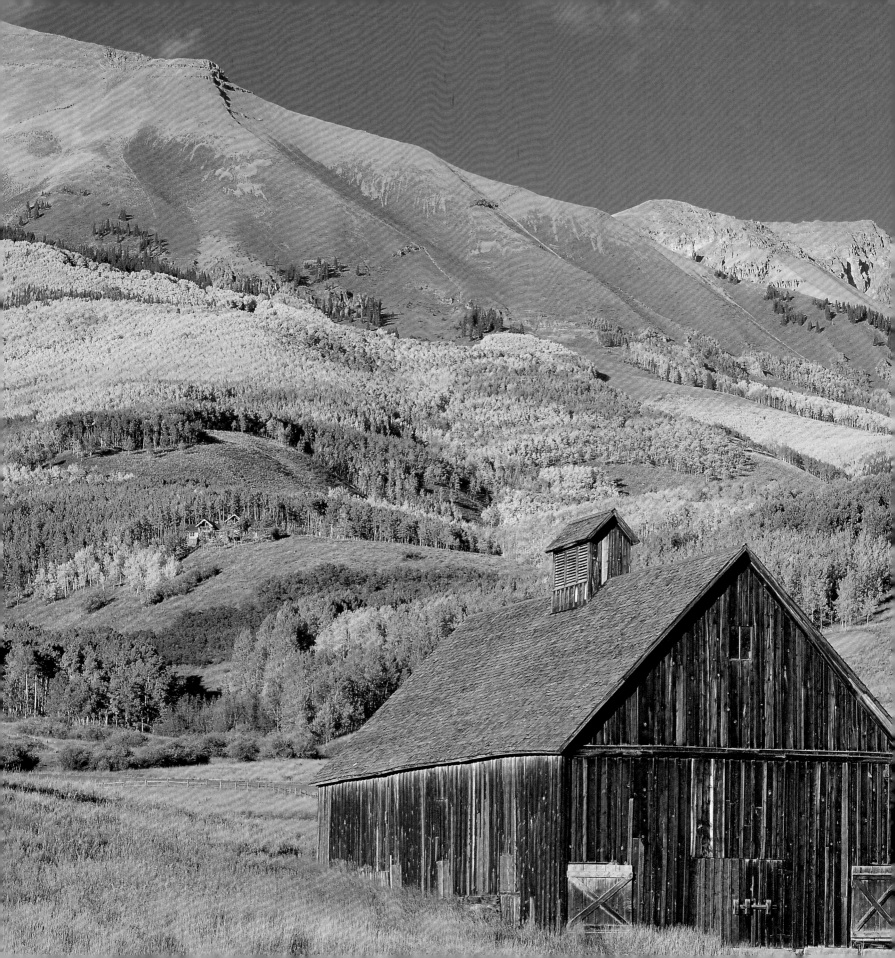

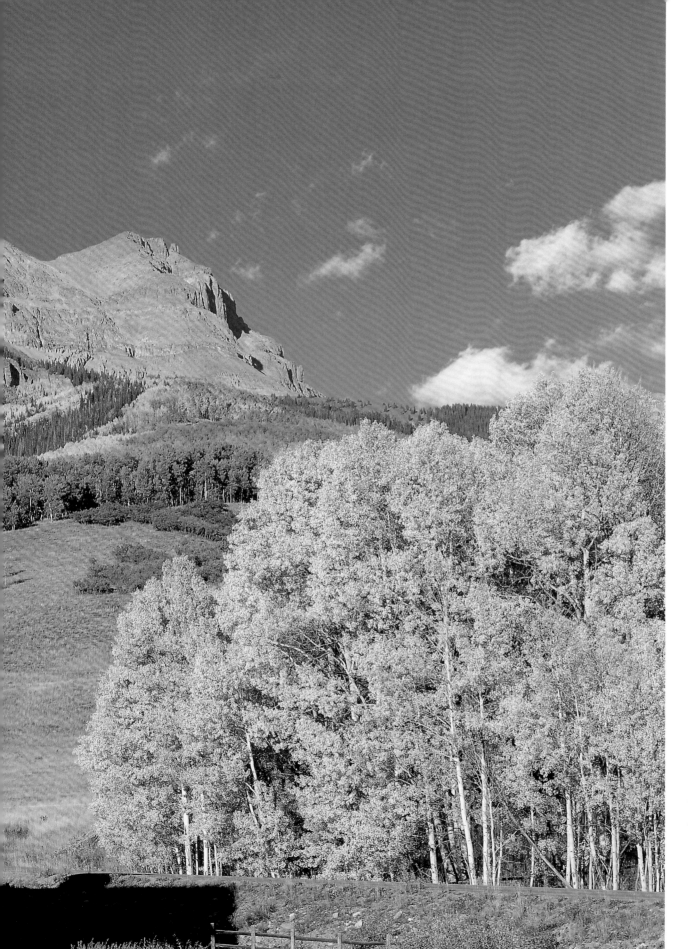

Near Telluride, an old barn creates a pastoral scene in the San Juan National Forest. This area was once home to an assortment of mines and claims. Remnants of these boomtown days can be seen throughout the forest.

The Uncompahgre National Forest boasts 100 peaks over 13,000 feet high, and draws climbers and mountaineers from around the world. The forest encompasses the unique Uncompahgre Plateau, a sprawling region 10,000 feet above sea level, bordered by dramatic red rock canyons.

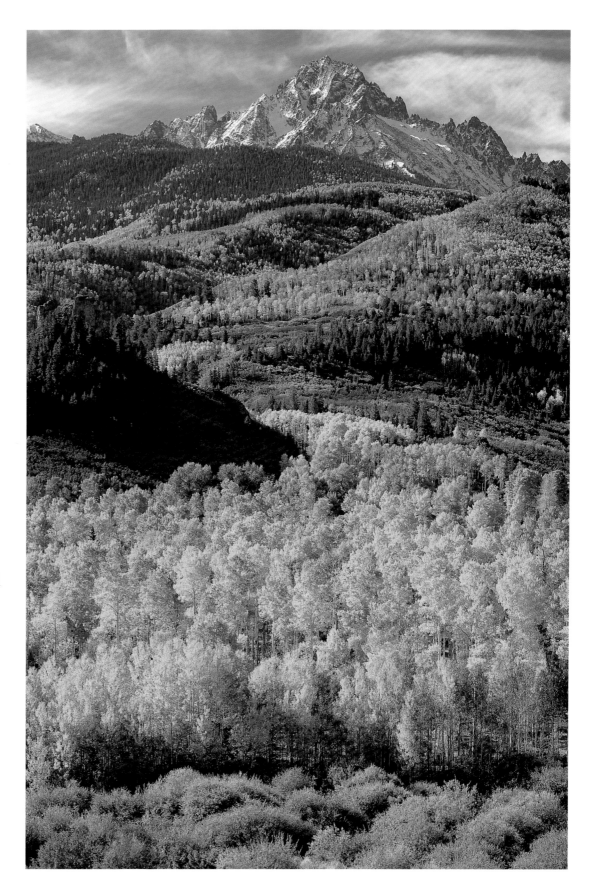

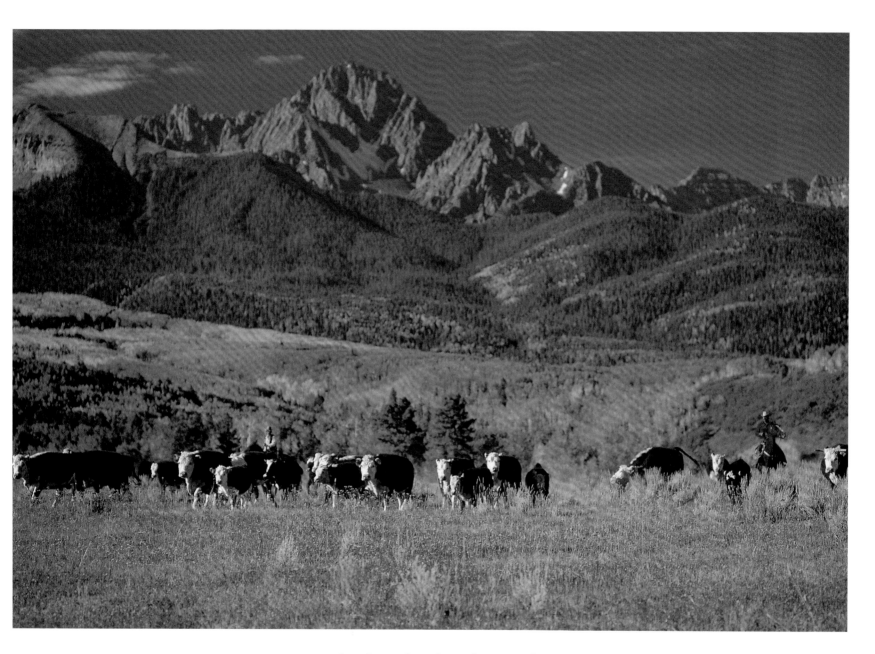

Cowboys herd cattle near the ranching town of Ridgway. Ranching was one of early Colorado's leading industries. A fierce blizzard during the winter of 1887-88 killed most herds and many ranchers went bankrupt.

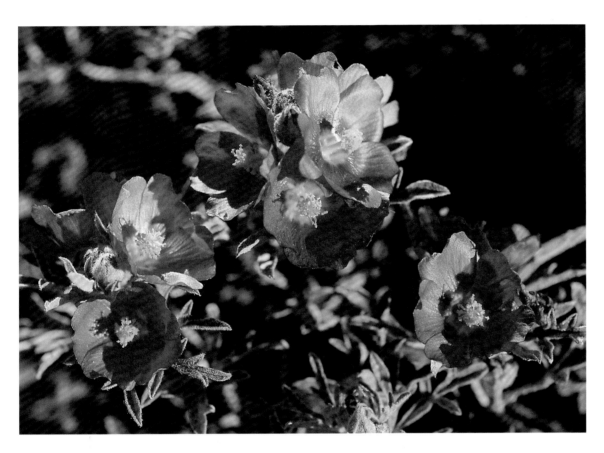

Scarlet mallow blooms add a burst of color to the dry prairie landscape.
There are over 30 species of this vibrant plant found throughout the country.

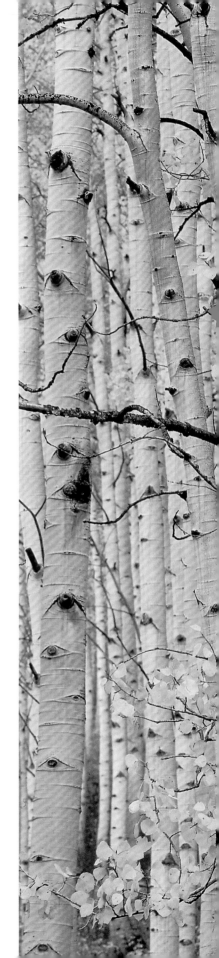

Aspen trees spread quickly in open areas. Before
the arrival of European settlers, Native people used
the tree to make poles, paddles and containers.
Medicinal tea was made from the bark.

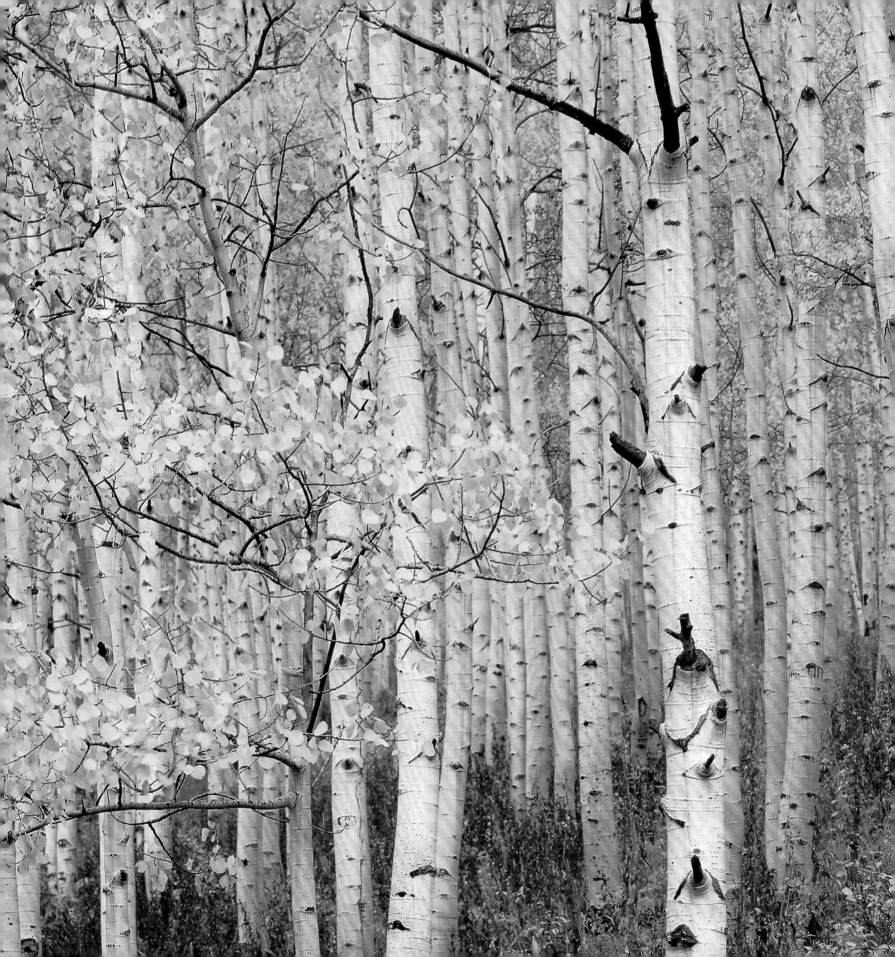

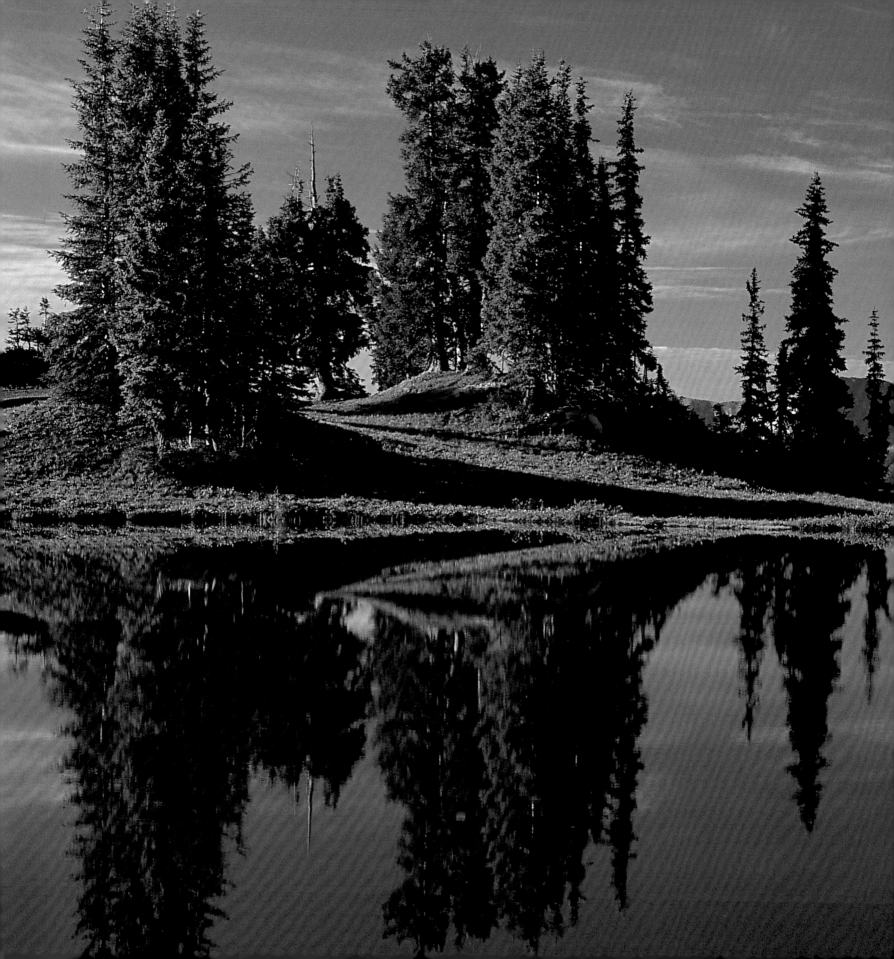

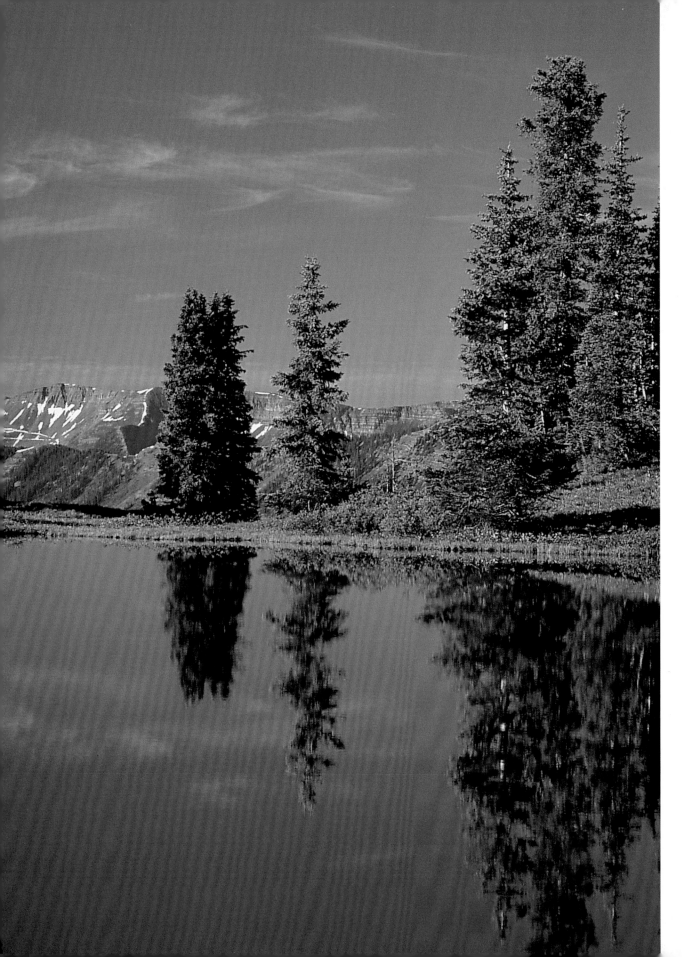

Gunnison National Forest borders Grand Mesa, White River, and San Isabel national forests. Together, they encompass more than four million acres of wilderness.

Photo Credits

Tom Till i, iii, 6–7, 12, 18–19, 24–25, 53, 76, 78, 80–81, 84, 88–89

David Brownell 8, 32, 58, 62, 71, 91

Douglas Peebles/First Light 9

Bob Waterman/First Light 10

Spencer Swanger/First Light 11, 23, 79

K. Redding/First Light 13, 17

Tom Algire/First Light 14–15

Wayne Lynch 16, 22, 27, 77, 92

Tim Fitzharris 20–21, 36

Terry Donnelly 26, 34–35, 43, 46, 47, 48–49, 64–65, 70, 72–73, 74–75, 82–83, 85, 90, 93

Pat Morrow/First Light 28–29

Ron Watts/First Light 30–31, 41, 42

Brian Parker/First Light 33, 60–61, 68

George H. H. Huey/First Light 37

A. Brinbach/First Light 38

Chase Swift/First Light 39, 40

Terry Donnelly/First Light 44–45

Barbara Magnuson 50–51

Rudi Holnsteiner 52

Larry Kimball 54–55, 63

Jurgen Vogt 56, 59, 66–67, 69, 86–87

J. Richardson/First Light 57

John Shaw/First Light 94–95